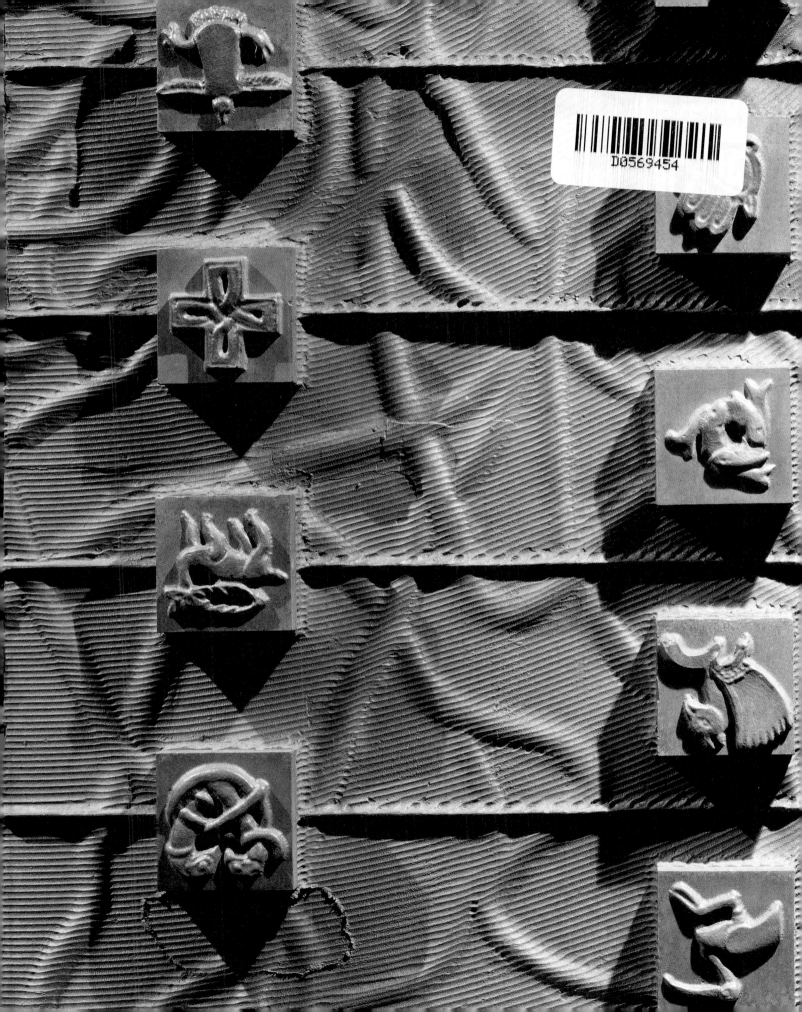

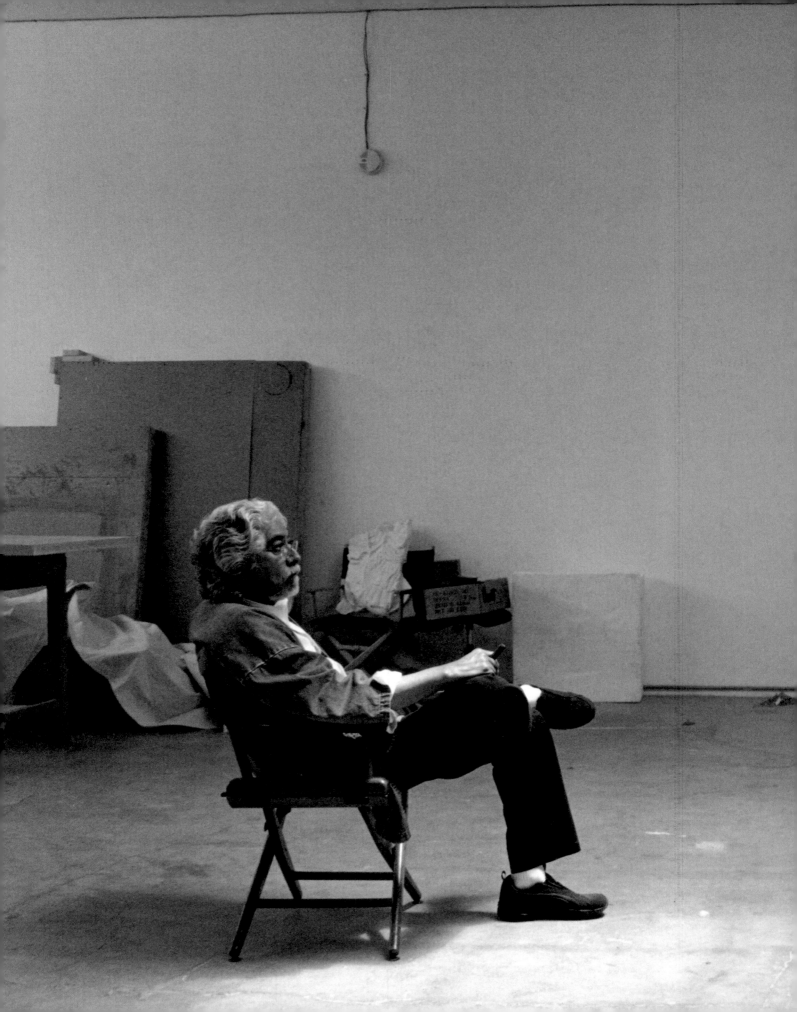

ROBERT GRAHAM

THE GREAT BRONZE DOORS

FOR THE CATHEDRAL OF OUR LADY OF THE ANGELS

JACK MILES

PEGGY FOGELMAN

NORIKO FUJINAMI

WAVE

VENICE, CALIFORNIA

Copyright ©2002 by Wave Publishing

"Our Lady of *Los Angeles*" ©2002 by Jack Miles
"Robert Graham's Bronze Doors: A Historical Perspective" ©2002 by Peggy Fogelman
"Technical Process and Realization" ©2002 by Noriko Fujinami
Copyrighted photographs from the following sources are used with permission:
©Alinari/Art Resource, NY; ©Foto Marburg/Art Resource, NY; ©Scala/Art Resource, NY;
©2002 Museum Associates/LACMA; ©2002 William Nettles for Robert Graham Studio;
©David Randle Photography

Wave Publishing
4 Yawl Street, Venice, California
310/306-0699
tsunami@primenet.com

Library of Congress Cataloging-in-Publication Data

Miles, Jack, 1942-
 Robert Graham : the great bronze doors for the Cathedral of Our Lady
of the Angels / Jack Miles, Peggy Fogelman, Noriko Fujinnami.-- 1st ed.
 p. cm.
 ISBN 0-9642359-3-5 (Hardcover) -- ISBN 0-9642359-8-6 (Limited Edition)

1. Bronze doors--California--Los Angeles. 2. Relief (Sculpture),
American--California--Los Angeles--20th century. 3. Mary, Blessed
Virgin, Saint--Art. 4. Cathedral of Our Lady of the Angels (Los
Angeles, Calif.) 5. Graham, Robert, 1938- I. Title: Great bronze doors
for the Cathedral of Our Lady of the Angels. II. Graham, Robert, 1938-
III. Fogelman, Peggy. IV. Fujinami, Noriko, 1950- V. Cathedral of Our
Lady of the Angels (Los Angeles, Calif.) VI. Title.
 NB1287.L67 M55 2002
 730'.92--dc21 2002010156
Design: Dana Levy, Perpetua Press, Santa Barbara, California
Copy Editor: Kathy Talley-Jones

Printed in the United States by Gardner Lithograph and bound by Roswell Bookbinding

Printed on 100 lb. Vintage Velvet book paper, typeset in Perpetua with Charlemagne

First Edition 10 9 8 7 6 5 4 3 2 1

CONTENTS

FOREWORD: THE THRESHOLD OF TRANSFORMATION *Reverend Richard S. Vosko* *7*

OUR LADY OF *LOS ANGELES* *Jack Miles* *13*

ROBERT GRAHAM'S BRONZE DOORS: A HISTORICAL PERSPECTIVE *Peggy Fogelman* *53*

TECHNICAL PROCESS AND REALIZATION *Noriko Fujinami* *69*

ACKNOWLEDGMENTS *124*

ABOUT THE AUTHORS *126*

ROBERT GRAHAM: BIOGRAPHY *127*

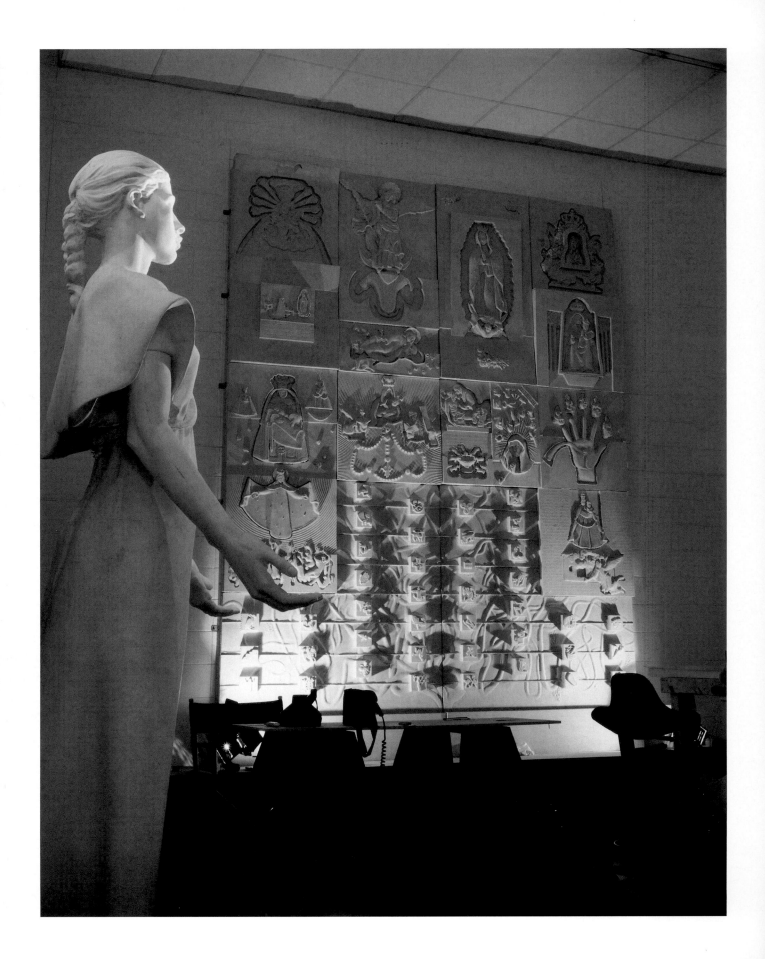

THE THRESHOLD
OF TRANSFORMATION

by Reverend Richard S. Vosko

Doors in religious places are thresholds, gateways into sacred arenas, spaces that become sacred because of the cultic ritual actions of the community enacted therein. Such doors represent one of many crossings a pilgrim makes in life. The late Joseph Campbell, a great scholar of comparative religion, reminded us that doors to a sacred place promise us what seems to be impossible in everyday life. The doors to a Catholic place of worship do the same. On the other side of the doors, the pilgrim believes sickness gives way to health, loneliness gives way to companionship, hatred gives way to peace, sin gives way to reconciliation, hunger gives way to sustenance, and even death gives way to eternal life. This is why in scripture Jesus Christ is called a door. (John 10)

This understanding of the sacred power of doors suggests that transformation can occur when a person crosses the threshold the doors mark. It is similar to what a catechumen experiences in the Christian rite of baptism by immersion. The new Christian who rises from the baptism pool is like a butterfly emerging from a cocoon. Similarly, the Great Bronze Doors of the Cathedral of Our Lady of the Angels signal the passage from an ordinary existence into the world of endless possibilities.

Art has the power to shape attitudes and values. In the history of Christian art, Mary, the Mother of God, has often been portrayed as a meek and mild, docile and humble handmaid—all virtues to be emulated to be sure. But that depiction will not necessarily speak to all women and men in the twenty-first century. This is why I believe that in creating his doors for the Cathedral of Our Lady of the Angels, Robert Graham has served us not just as an artist but also as a theologian or, more precisely, a

< **A full-size plaster cast of the Virgin figure is profiled in the artist's studio—on the wall are casts of the manifestations of the Virgin panels.**

7

Mariologist. He has given us a new insight into who Mary is and what she can be for young and old women and men of this age. Graham's Virgin is a model for the peoples of the Americas where women still struggle for recognition, equality, and respect. Perhaps the comments of the Cathedral Arts and Furnishings Committee summed it up most clearly: She exudes "strength and confidence like a woman full of courage and hope." Many people will be able to identify and take refuge with this kind of Mary. More than a meeker, milder, more docile figure, she can call them to be transformed, to be full of grace.

Rather than depict ancient stories from the Bible, Graham taps into the collective consciousness of the people who live in the Archdiocese of Los Angeles. In this book, Jack Miles explains how Graham understands the Virgin as "Our Lady of *Los Angeles*"— not of angels, then, but of the people of this city. Grasping the cultural eclecticism of the population, Graham built into the lower doors many varied symbols selected to stimulate the memory of older generations who will recognize them and take pride in explaining them to generations X and Y. These indigenous or naturalized symbols connect the old with the new, the past with the present—connections that are so important in a sprawling megalopolis where inequity abounds but where pride prevails as well.

But doors to sacred places are also touchstones. Later in this book, Peggy Fogelman carefully describes the artistic and historical context for doors to great buildings. Famous doors (the Cathedral in Chartres, Notre Dame in Paris, and so on) present spectacular sculptural iconography. One can read in them, if not touch, stories where the chief protagonists were ordinary people transformed—saints and blessed ones who crossed the same threshold of faith once upon a time. The tympanum in a classic

cathedral typically features Christ the High Priest surrounded by more saints, silent sentinels, if you will. Various storyboards in the door panels themselves put the pilgrim tourist in touch with biblical passages from both testaments. Not so with Robert Graham's doors. With Mary as their central figure, these doors will be bold and different. Aside from being architecturally massive to an unprecedented degree, they challenge the assumptions of what a door to a great cathedral can be.

In the final section of the book, Noriko Fujinami documents the doors' realization with a fascinating photo essay, detailing the creative and technological processes Graham utilized in making the bronze doors.

When the doors and the tympanum with the Virgin figure were done but not yet transported to the cathedral building, I visited Graham in San Dimas, California, where the doors were constructed. As in the past, we sat and talked about his art. I asked him how he felt now that his creation was almost finished. In so many words, he said, "I am exhausted!" Yet I could sense his awareness that he had created something powerful and extraordinary, even though it drained him. I mused to myself that this artist had gone through a transformation himself.

In years and even centuries to come, this is what his Great Bronze Doors will do for hundreds of thousands of pilgrims—create opportunities for profound transformation in the sacred realm of God.

Richard S. Vosko, Ph.D, a Catholic priest, was the liturgical and public art consultant for the Cathedral of Our Lady of the Angels.

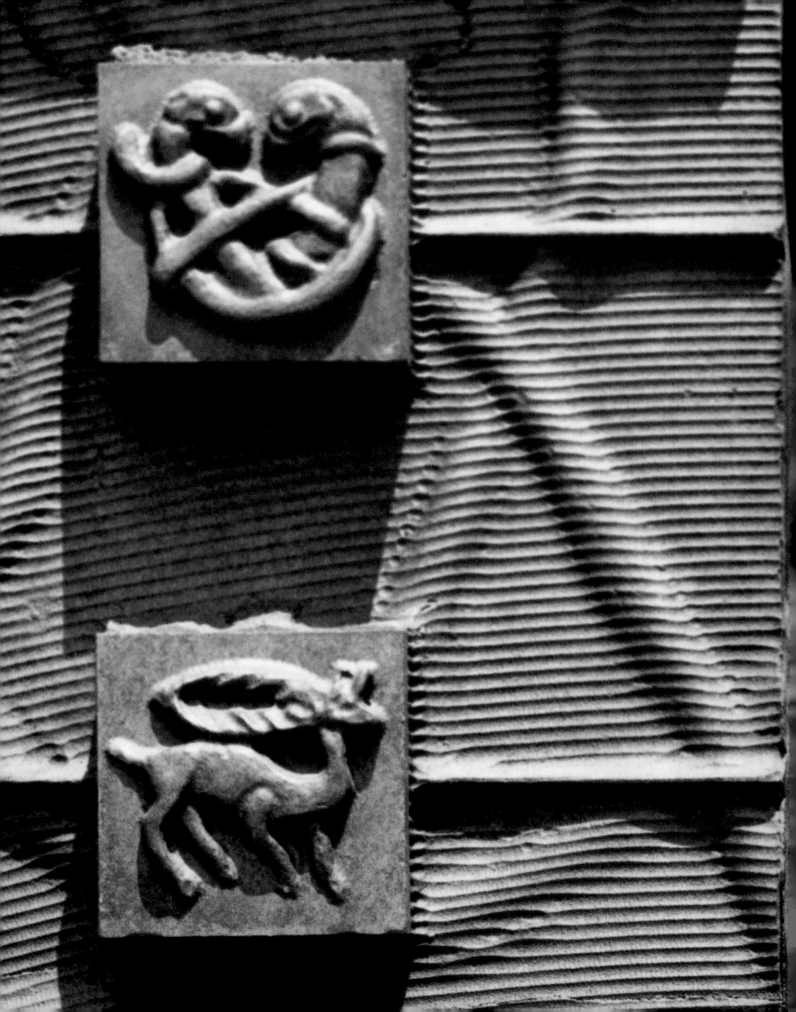

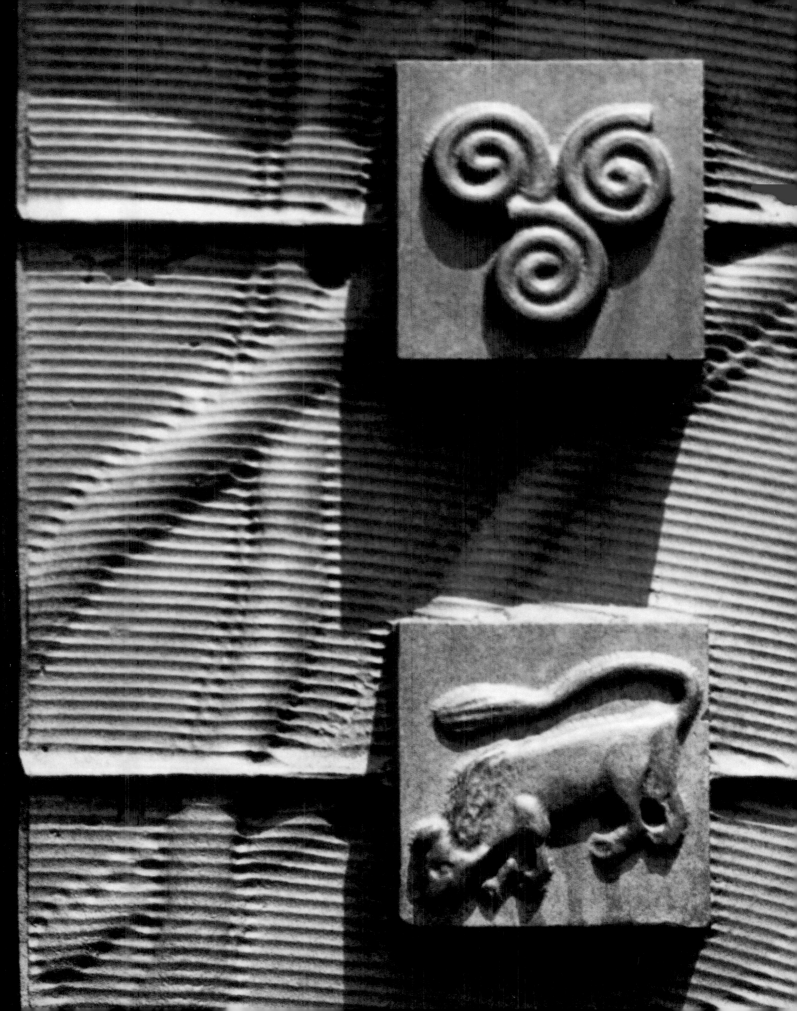

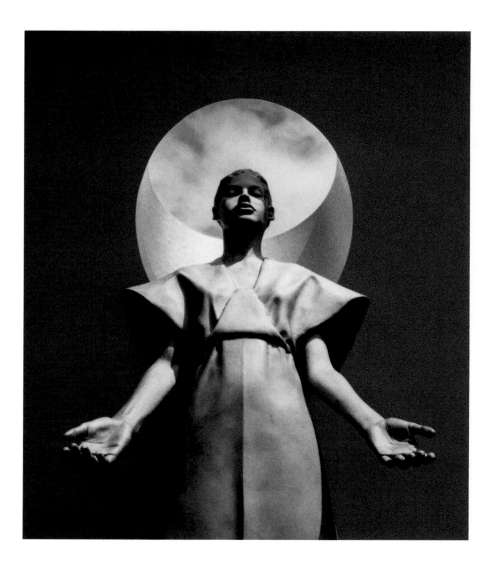

OUR LADY

OF

LOS ANGELES

by Jack Miles

WHO IS SHE, the woman in whose honor this imposing temple has been built, who stands with arms mysteriously outstretched above its great doors? She is, in the first place, the beautiful, forever-anonymous, ethnically mixed young woman whom sculptor Robert Graham recruited as his model when he was commissioned to create the doors in 1998.

Graham chose her for a reason. Ernesto Zedillo, then president of Mexico, had a year before referred to Los Angeles as the world's second most populous Mexican city. One of every six Hispanic Catholics in the United States resides in the Archdiocese of Los Angeles. Yet the visionary who commissioned a new cathedral for this "Mexican" city is an Irish American, Cardinal Roger Mahony, and the cathedral's director of construction would be the Irish-born Brother Hilarion O'Connor. With forty or more other ethnic groups represented in this sprawling archdiocese, the cathedral's signature icon had to be "Our Lady" for all of them. Graham chose his model with all of them in mind.

Who is she? During the life of an edifice designed explicitly to last five hundred years, the woman who stands radiantly above its doors "clothed in the sun, with the moon under her feet" (Revelations 12:1) will become by degrees neither simply Our Lady of the Angels, after the name of the cathedral, nor simply *Nuestra Señora de los Angeles* but a bilingual combination of the two: "Our Lady of *Los Angeles.*" That mestizo phrase will refer with equal directness to the statue itself and to her whom the statue represents. Moreover, "Our Lady," rendered in bronze, will be a durable symbol of the metropolis itself whose patroness she has been ever since an ethnically mixed group of

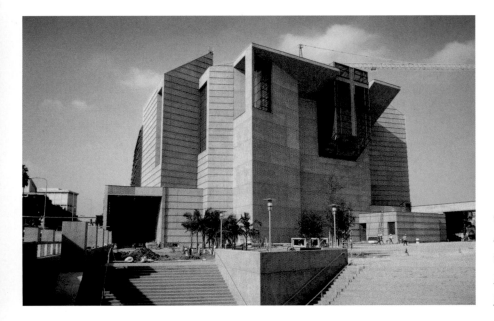

The cathedral under construction with the portal, three stories square, awaiting placement of the doors.

colonists from Mexico—Europeans, Africans, and Native Americans—named their settlement in her honor in 1781: *El Pueblo de Nuestra Señora, la Reina de los Angeles.*

The announcement in January 1995 that a new cathedral would be built in downtown Los Angeles came as something of a surprise. True, the existing cathedral, St. Vibiana's, had been all but irreparably damaged a year earlier in the Northridge earthquake; yet no new Roman Catholic cathedral had been built in the United States in forty years, and there were some who thought that the bricks and mortar era in American Catholic history was closed. It was not a foregone conclusion that a new cathedral would be built or, if it were, that it would be built downtown. That the commission for the cathedral went, after a world-wide search, to the accomplished Spanish architect and Pritzker Prize winner José Rafael Moneo came as a second surprise, though a smaller one. The architectural and artistic maturity of American church leadership was, by any measure, greater at the end of the twentieth century than at the mid-century high tide of church construction. A surprise within that surprise was that the most important single artistic commission in the new undertaking—responsibility for the enormous doorway, three stories square, that was so salient a feature of Moneo's design—went to Robert Graham, a sculptor of great distinction but not one known for his work on any religious theme.

Graham met the challenge by, in the first instance, taking Cardinal Mahony and his key consultants at their word that this project was to be construed as an event not just in the life of the church but in that of the city, the country, and even—because of the cultural transformation being wrought by south-to-north immigration—the Americas as a whole. This was then to be no simple exercise in Spanish Mission nostalgia with "Ramona" playing softly in the background. Moneo's building promised to be one of bold and contemporary angularity. Graham's doors would complement that angularity, looking to the past as well as to the future and remembering, above all, the human constituency by which—far more than by real estate—the American Catholic Church of the twenty-first century will be defined.

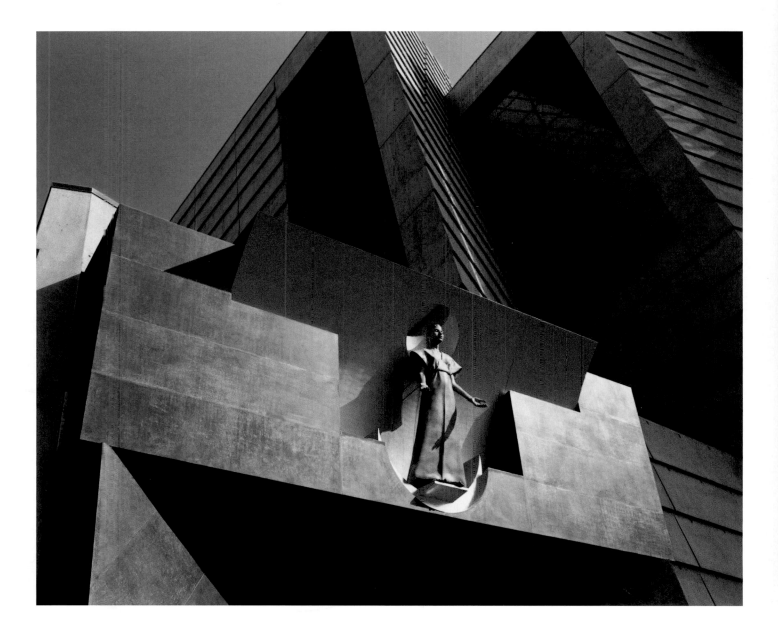

THE TYMPANUM

As Our Lady of the Angels, the woman of the doors recalls most immediately—in Graham's complex and subtle iconographic program—the ultimate destination of the Christians who will gather in the cathedral. The golden center of the tympanum, the fixed upper plane of the door installation, is an evocation of heaven. Though ultimately Graham broke with the common convention of representing Mary, the mother of Jesus, with a halo—an element some earlier versions of the statue did incorporate—he alludes to that convention by piercing the wedge of the tympanum above Mary's head so that sunlight, representing God himself, may "clothe" her (Revelation 12:1) as it reflects off her figure and off the gilt of the inverted arch in which she stands, her figure tilted imperceptibly forward.

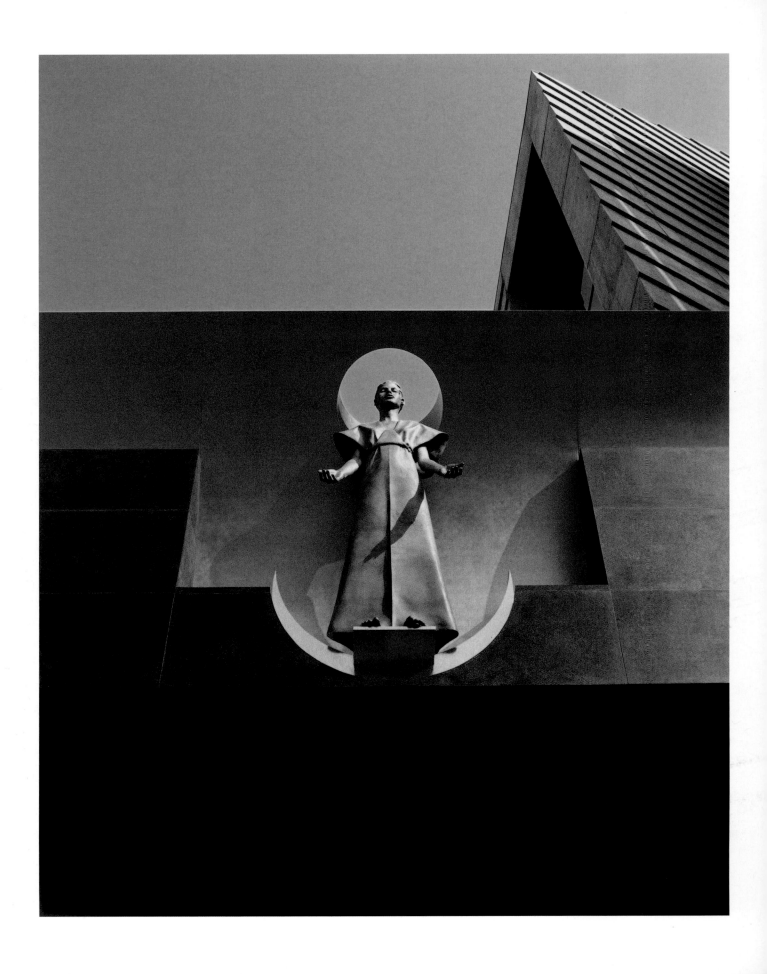

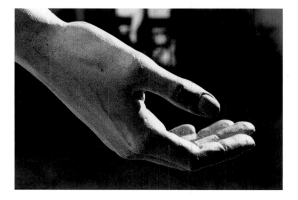

Lady who lends power and meaning to such different places draws power from them as well. She is like a miraculously talented actress who discovers something new within herself wherever she performs by drawing theatrical power from each successive audience.

Yet the performance Our Lady of *Los Angeles* gives as St. Mary the Worker is not so much radical as it is radically conservative, for Miriam of Nazareth was born in an era when unrelenting physical labor was the lot of all but the tiniest minority of women. The innumerable portrayals of her, over the centuries, as a delicate aristocrat are historically indefensible. Little as we know of the historical Mary, we can be certain that she was a woman who worked with her hands, for in her time and place all ordinary women did so. Whence the second meaning of Mary's gesture as Graham has captured it in the strong hands of a woman "not too proud to work," capable hands, hands ready to help. Behold, they seem to say, the unpampered domestic servant of the Lord.

Debate among Cardinal Mahony's artistic consultants—briefly intense about the Madonna's bare arms—was somewhat less so about her bare head. Iconographic precedent for dispensing with the familiar veil was, after all, easy to find. Yet in portraying the head of Our Lady of the Angels, Graham's break with tradition goes far beyond the absence of a veil. More than once during his work on the doors, the sculptor commented that he did not want his Queen of Heaven "to look like Mary Pickford." What did he mean by that? He meant that he did not want her to project—as had so many earlier Madonnas in American Catholic churches—the cloying innocence of "America's Sweetheart" circa 1925. One way to ensure this was to give her a racially indefinable physiognomy. At the risk of caricature, Graham's Mary may be said to have a Caucasian nose, Asian eyes, African lips, and straight, coarse hair worn in a thick Native American braid. But the visual language of this portrait is not caricature but the subtlest of characterization, most daring where it is most elusive, for what Our Lady of *Los Angeles* projects is not melting innocence but cool knowledge. She may be the comforter of the afflicted (another of her many titles), but this fearless young woman is nobody's sweetheart.

Who is she? She is, in sum, a woman at a peak of self-consciousness and self-possession, the *mulier fortis* or proverbial "valiant woman" of the Book of Proverbs, from whom we might well expect the exuberant words of St. Luke's *Magnificat*:

My soul glorifies the Lord,
 and my spirit rejoices in God my Savior,
 for he has noticed the humble condition of his maid.
From now on, why, all generations will call me blessed,
 for the Mighty One has done great things for me,
 and holy is his name.
He has shown strength with his arm.
 He has scattered the proud in the conceit of their hearts.
He has put down the mighty from their thrones,
 and raised up the lowly. (Luke 1:47-49, 51-52)

It was Graham's intent, stated in writing (see note 4, page 42), to portray Mary as Queen of the Angels, a lowly woman raised up to the highest of all thrones. The challenge he set himself was to make her majestic while dispensing with all the usual trappings and signals of majesty: no crown, no scepter, no throne, etc., only her regal beauty, her invincible self-possession, and the abstract perfection of her gown, like an apparition in its wrinkle-free smoothness and impossible triangular symmetry.[5]

Though Catholic dogma defines Mary as sinless, the greatest paintings of Mary have never made her merely, vacuously innocent. Sandro Botticelli, to name one master, paints her as so breathtakingly beautiful that any man might fall in love with her, and yet there is always a trace of sorrow in her eyes. In the "Madonna of the Book," for example, of Milan's Poldi Pezzoli Museum, Botticelli's baby Jesus looks innocently up into his mother's eyes, while she looks pensively past him toward the open page of a book. A Bible open to a prediction of his passion and death? Perhaps, for a tiny golden crown of thorns dangles like a strange toy from the baby's wrist, and he holds three miniature golden nails in his chubby left hand. To a point, then, there is precedent for Graham's "knowing" virgin, yet Graham goes beyond Botticelli. More than the bare arms, the strong hands, and the statuesque, head-high carriage of his Mary, it is the indefinable expression on her face that breaks precedent. Seen in one moment, she can seem an athlete, a paragon of physical poise and strength. Seen in the next, she can seem a bodhisattva, suspended, almost disembodied, in the preternatural calm of beatific vision. Seen in one moment, a domestic servant; in another, the Queen of Heaven. Much will rightly be said about the complexity of Graham's conception and the technical virtuosity

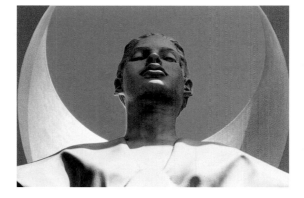

of its execution, yet the last word will never be said about this face. The ability of a great sculptor to convey meaning through a face transcends all else. It is like the ability of a great composer to convey grief or love through a melody, and yet it is more elemental even than that, for it speaks to who we were when, before we were capable of comprehending speech or discerning melody, we saw and understood the first face that bent over our infant selves. "There's no art to find the mind's construction in the face," Shakespeare wrote in *Macbeth*, but then Shakespeare was a writer, not a sculptor.

THE OUTER DOORS AND THE SCORING

The Great Bronze Doors of the Cathedral of Our Lady of the Angels function, artistically, as an immense, vertical bronze mobile. Fully one hundred square yards in area, this twenty-five ton mobile is so large that when it begins to move, the cathedral itself seems to move as well. The larger, outer doors, each in the shape of an inverted L, are hollow, narrowing from a yard wide at the far left and right to just inches wide in the middle. Within the steel armature to which the bronze plates of the outer doors are attached is a pair of motors that can open the solid inner doors. Below each hollow outer door is an additional powerful motor that can open the doors in stately sequence. Though the tympanum is bolted to the cathedral walls for extra stability, the movable doors themselves are not hinged to the building. They do not hang on the cathedral, but stand in front of it. They rotate on a pair of massive steel shafts that rest on conical bearings five feet below the bottom of the doorway (see pages 108–9).

The Reverend Richard S. Vosko, a consultant who worked closely with Cardinal Mahony in designing the artistic program for the cathedral, sees the doors to the cathedral as, metaphorically, the doors to the sheepfold of Christ, the Good Shepherd. Father Vosko quotes John 10:9: "I am the door; and if anyone enters by me, he will go in and out and find pasture." Because of the unique floor plan of the cathedral of Our Lady of the Angels, its doors do not open directly upon its nave or provide an immediate view of its high altar. They open, instead, on a lofty and slightly eerie ambulatory that runs along a side wall of the cathedral and, by architect Rafael Moneo's intention, delays and heightens the impact of arrival in the central sanctuary.

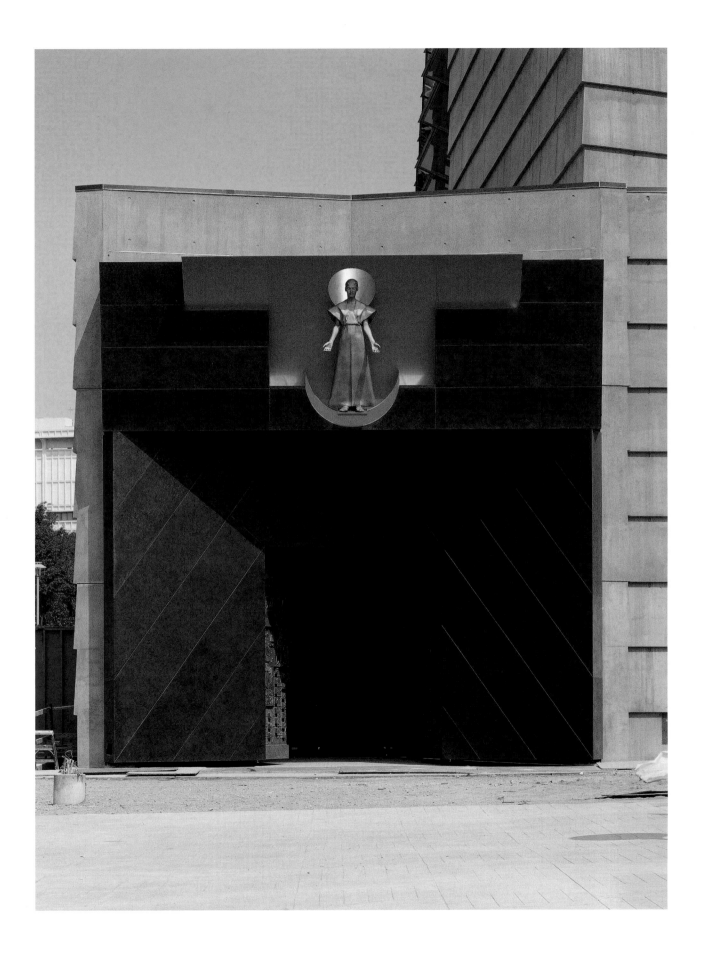

As the massive bronze doors yawn open on this dark and enigmatic corridor, the visitor may feel a touch of simple fear, as if he were a sheep being led into a tunnel. But the statue of Mary acquires a new and reassuring meaning when the doors stand open. Rather than beckoning upward to heaven, the Queen now seems to direct the visitor inward, into her sanctuary. Her gesture no longer seems to say "Behold, the handmaid of the Lord" but rather "Behold, the temple of the Lord." It is the Lord, and he alone, who will be worshipped here. But the temple is hers as well as his: It bears her name. On a Sunday morning, when the doors are fully open and sunlight falls directly on the eastward-facing tympanum, its gilt center can blaze like a pair of golden wings, and Mary can seem to hover above the cavernous emptiness of the entrance like a goddess.

Mary is not a goddess, but what is her relationship to God? In Catholic tradition, theology as the study of God (*theos* in Greek) has two companion disciplines: Christology, the study of Christ, and Mariology, the study of Mary. A great historian, Jaroslav Pelikan, wrote in *Mary Through the Centuries: Her Place in the History of Culture*: "The most important intellectual struggle of the first five centuries of Christian history—indeed the most important intellectual struggle in all of Christian history—took place in response to the question of whether the divine in Jesus Christ was identical with God the Creator" (p. 48). As that question was resolved by the development of the doctrine of the Holy Trinity, Pelikan shows, Mary's understood importance grew ever greater until in A.D. 431 the Council of Ephesus awarded her the definitive title *theotokos*, a Greek word meaning "Mother of God."

As a human being, Mary is, like all human beings, a child of God. But when God chose to become a Jew, suffering and then triumphing with and for his chosen people and saving all mankind in the process, he chose her to be his human mother. Though tradition has never spoken of Mary as the bride of the Holy Spirit, it is scarcely a break with tradition to say that she has a distinctly different relationship to each member of the Trinity: to the Father as her father; to the Son as her son; and to the Holy Spirit, by whose power she conceived the Savior of the World, as her partner in the work of redemption.

How can these subjects, which have filled not just volumes but libraries, be included in a sculpture that, by the limitations of the medium itself, must dispense all

but entirely with language itself? Shakespeare spoke of "sermons in stones," but can any architecture incorporate the conceptual complexity of the Trinity and Mary's relationship to it? The answer that Christian architectural tradition has given to that question is: Yes, it can, given an adequate spirit of play between builder and visitor. Mary is not quite alone in the tympanum of Graham's doors. Look closely (page 22): The tympanum is scored with three horizontal lines—one each for the Father, the Son, and the Holy Spirit. The Trinity is suggested again in the equilateral triangle scored on the outer doors, a triangle whose upper point is exactly below Mary's feet. If the shortest diagonal lines on the outer doors, those at the upper right and left corners are extended up and down, they inscribe an equilateral triangle whose upper point lies just above the Virgin's head.

Does this scoring truly evoke the Trinity? It does so if the viewer takes it so. And this is just the beginning of the game: The Trinity is embedded at several other points in this composition as well, upon each of which theological meanings can be projected.

But why? Where does the idea of the Trinity come from? What provoked the Fathers of the Church to commit Christianity to such an improbable notion? And does it still matter to the Church? Jaroslav Pelikan answers that question as follows:

> ...the doctrine of the Trinity was not as such a teaching of the New Testament, but it emerged from the life and worship, the reflection and controversy, of the church as, in the judgment of Christian orthodoxy, *the only way the church could be faithful to the teaching of the New Testament* (p. 9, emphasis added).

The idea of the Trinity is the end result of a kind of high-stakes literary criticism, a way to make sense of apparent contradictions in the Gospels. It has to matter to the Church if the Bible matters to the Church. The Gospels speak of the Father and the Son often as two but sometimes as one; thus, Jesus says, "I and my Father are One" (John 10:30). By contrast, the Gospels speak of the Spirit and the Son often as one but sometimes as two; thus, when Jesus breathes his spirit into his apostles in a vividly intimate scene after his Resurrection, he does not say, "Receive my spirit" but "Receive the Holy Spirit" (John 20:22), as if referring to a separate entity. The question to which the Trinity is an answer (if not the only possible answer) is a question forced by the Gospels themselves—namely, how can all these statements be true at the same

time? But if such a question can be asked, how on earth can it ever be *sculpted*? Look at the tympanum again, and this time count spaces instead of lines: four spaces, one each for Matthew, Mark, Luke, and John. They are the eternal quartet—"mamalujo," James Joyce called them in *Finnegans Wake*—who collectively created the baffling question to which Trinitarian doctrine became the canonical answer, with such surprising consequences for the place of Mary in Christian teaching.

Given a responsive spirit of play, this numerological game can continue through many moves. Three lines plus four spaces make seven for the seven days of creation. Three lines times four spaces equal twelve for the twelve apostles. If the top and bottom edges of the tympanum are counted as two additional lines, then there are five lines. Add four spaces to five lines, and you get a total of nine for...the nine choirs of angels![6] On the framing doors beneath the tympanum, there are seven diagonal lines on the left and a second, mirroring seven on the right. Suggesting what? A first approximation might be: On the left, the seven cardinal virtues: the three theological virtues (faith, hope, and love) plus the four moral virtues (justice, temperance, courage, and prudence). On the right, the seven sacraments: baptism, eucharist, confirmation, penance, matrimony, holy orders, and the anointing of the sick.

When the doors are closed, these converging lines form a chevron pointing toward Mary and toward heaven. When the doors are opened, the same lines point both upward and inward—into the cathedral where the sacraments are administered and the virtues preached. The lines are, so to speak, scored for performance.

Needless to say, no one will count lines and spaces on a first visit, much less run through all the permutations of adding and/or multiplying them. Remember, though, that devout Catholics attend church every Sunday—fifty-two times per year or more. On, say, the thirty-fourth visit to this cathedral, the thirty-fourth passage through these doors, who knows what might come to the pious mind? Traditional Christian art is quite deliberately dense with content in just this way. It gives something immediately, but holds something else back for a later date or a more earnest inquiry.

In Graham's image, Mary appears, significantly, without the infant Christ in her arms but surrounded by golden light. The effect recalls words that a parish priest of Tejupilco, Mexico, said in the seventeenth century of the Virgin of Guadalupe:

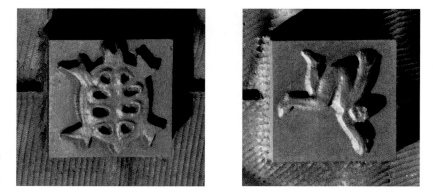

Chinese Turtle

Falling Man

...she carries in her arms not the Word made man but the Son of God transformed into light, which is that which illumines her hands....Mary appears...without the God Child in her arms, but surrounded by light; the miracle is so stupendous because the mystery is so ancient, since it takes its origin in eternity, when the Son of God was light, *erat lux vera* [he was the true light], and he was not made man until much later.[7]

THE INNER DOORS: LOWER REGISTER

The statue of Mary and the theological/Christological/Mariological lines that Graham has scored around her on the tympanum and on the framing doors beneath it represent, taken together, the realm of mythic or cosmic history. Below them and within them, at the center of the composition, the image-crowded inner doors have a noteworthy inner division of their own. The larger upper register gathers a set of images associated with the history of Mary's ever-changing presence in Christian history. The smaller lower register gathers an assortment of ancient symbols, threshhold images, most of which antedate Christianity, though many have been Christianized as the centuries have passed. This lower register takes the form of an inverted T, as if to mirror the upright golden T of the tympanum. If the upper, golden T stands for revelation, the lower, inverted T stands for what we might call religious instinct.[8]

Thus, Graham's doors may be read theologically from the top down, or anthropologically from the bottom up. A child approaching these doors might come away remembering only the Chinese Turtle (above), but a turtle is a worthy memento. In various world mythologies, including the Japanese and the Indian as well as the Chinese, turtles appear at the beginning of time, or a tortoise is believed to hold the world on its back. Turtles and tortoises end up playing such roles because they are animals to which any child (or the child in any adult) is spontaneously drawn. They are inherently apt for metaphorical use.

In the same anthropological vein, imagine a troubled adult, a stranger to church ritual and church talk, finding his or her way to the cathedral and pushing on the icon of the Falling Man (above) as if it had been placed there as a knob to open the door. Whether the door moves or not is secondary. What matters is that the Falling Man

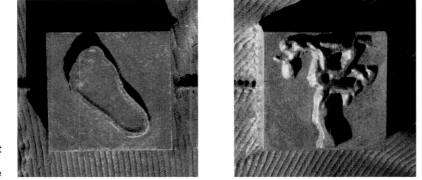

Footprint

Tree of Jesse

is a "natural symbol," an inherently suggestive icon that in more senses than one opens inward on a cathedral.

The lower register of Graham's inner doors is an assembly of such natural symbols. Catholic tradition has sometimes called the human activity that produces such symbols "natural religion" and has called reflection upon them "natural theology." It might be simpler to say that they embody the universal human suspicion that the world is not self-explanatory, that it points to something beyond itself, something not just beyond what the human eye can ever see but beyond what the human mind can ever comprehend. The world as beyond human emotional and intellectual capacity can seem alternately more wonderful and more terrible than it normally seems. Religious and pre-religious symbols are intended, for better and worse, to serve as reminders that the world as it normally seems may not be the world as it really is.

Normal men and women in their normal frame of mind ask of religion, "What is it for?" Why shouldn't they? Yet religion has a way of asking back, according to the Japanese philosopher of religion Keiji Nishitani, "What are *you* for?"—a question intended to jar the questioner out of his or her normal frame of mind and surprise him or her into spiritual freedom. What starts the process of spiritual liberation is often, paradoxically, a moment of alienation, which is to say a moment that turns a man or woman into a stranger, an alien, in the world that normally feels like home. Animals not infrequently produce this effect. When an animal draws you into its world, you feel, momentarily, a stranger back in the world of your fellow humans. It is in this way that animals can seem oddly holy. They remind you that you yourself may be, in this world, not a resident but a visitor, a pilgrim passing through. Animals are "other," and their otherness, their differentness, reminds you of your own.

Many animals appear in the lower register of Graham's inner doors, but so do other suggestive or numinous objects—a footprint, for example (above). The feelings such objects provoke are not the core of religion, but they are the threshold to it. They belong, then, not in the sanctuary but just where Graham has placed them: on the door, and indeed on the lower, reachable, touchable part of the door.

Pre-religious, threshold images often live on, of course, within fully developed,

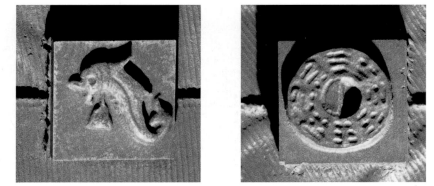

Dolphin

I Ching

formal religion, but they bring their past with them. Thus, the Tree of Jesse (see page 27) is religiously Jewish because Jesse, King David's father, was the founder of the dynasty from which the Jewish Messiah, a "new shoot from the Tree of Jesse," was to come. But the Tree of Jesse is also, first and perhaps foremost, simply a tree, with all the natural symbolic power of the tree: strength, durability, shelter, long life, reawakening after dormancy, and so forth.

Similarly, the dolphin (above)—celebrated in Greco-Roman mythology for saving the lives of shipwrecked sailors—became, after the rise of Christianity, a symbol of Christ the Savior. But neither pagan legend nor Christian imagination was necessary to make the dolphin a mesmerizing animal. Who can deny the allure of the dolphin who has once seen a school of them breach the surface of the Pacific in perfect synchrony?

Of all the threshold images that Graham assembles in the lower register of the inner doors, the grapevine—twining behind the others and then disappearing into the upper register and, as it were, into the cathedral itself—is clearly the most important. "I am the vine," Christ said, "you are the branches. Whoever abides in me, and I in him, will bear much fruit" (John 15:5). The grape-harvest is proverbially a time of gladness and merry-making. But grapes yield wine, and wine is the metaphor Christ used for the blood he would shed to redeem mankind.

> Then he took a cup, and when he had given thanks, he gave it to them, and they all drank of it. He said to them, "This is my blood, of the new covenant, which is poured out for many. Truly I say to you, I shall not drink again of the fruit of the vine until that day when I drink it new in the kingdom of God." (Mark 14:23-25)

The liturgy of the Eucharist, the drama for which the cathedral itself is only the stage, commemorates this moment in the life of Christ and the unfinished story it began. As St. Paul put it, "As often as you eat this bread and drink the cup, you proclaim the Lord's death until he comes" (1 Corinthians 11:23-26). Those who know and care about the Christian story—initiates, so to call them, who are waiting for the Lord to come—will think of Paul's words when they see the vine and the grapes on the doors and, spiritually speaking, will be through the doors already and kneeling in the sanctuary. But those who see the same image and think only threshold thoughts of abundance, nourishment, and intoxication will have made no mistake. In the Catholic tradition, grace builds on nature.

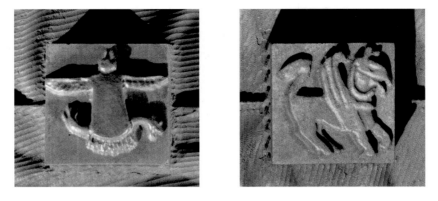

Chumash Condor

Griffin

In the last analysis, these polyvalent natural symbols have been placed on the door of the cathedral not just because they constitute in themselves points of entry to the religious experience but also because they are a reminder that the cathedral, though built by Roman Catholics, has not been built for them alone. Cardinal Mahony and Monsignor Kevin Kostelnik, who will serve as pastor of the cathedral parish, insist that the cathedral of Los Angeles is for everyone who lives in the City of Los Angeles as well as for the many millions who just pass through. Not all forms of Christianity take the city as their basic administrative unit, but Catholic Christianity has always done so—with the consequence that major Catholic cathedrals have always tended, wittingly or otherwise, to accommodate ideas and images remote from the Catholic tradition itself and yet comfortable enough within it, like snug stowaways in a huge cargo ship.

There may be no example of a European cathedral with the I Ching carved in an out-of-the-way corner, but Los Angeles's Chinatown begins barely one hundred yards from the corner of Temple and Hill where the cathedral stands. In Los Angeles, then, the I Ching (page 28) must surely be taken on board. So also the Chumash depiction of a California Condor (above), the Chumash being the Native American tribe whose ancestral home included the Pacific Coast opposite what is now Los Angeles. (*Malibu*, a Chumash word, is said to be the oldest place-name in California.)

It would be tedious, if unpredictably fascinating, to list the traditional meaning of every symbol in the lower register of the inner doors. J.E. Cirlot's *A Dictionary of Symbols* calls the griffin (above):

> A fabulous animal, the front half of which is like an eagle and the rear half like a lion, with a long, serpentine tail...always to be found as the guardian of the roads to salvation, standing beside the Tree of Life or some such symbol. From the psychological point of view it symbolizes the relationship between psychic energy and cosmic force. In mediæval Christian art...associated with signs which tend toward ambivalence, representing, for instance, both the Saviour and Antichrist (p. 133).

For each of the symbols on the doors, a comparable entry could be produced, but the effect of a complete catalog would be at odds with the intent of Graham's bas-relief, which is, clearly, not to achieve documentary completeness but to suggest endless—and endlessly welcoming—variety.

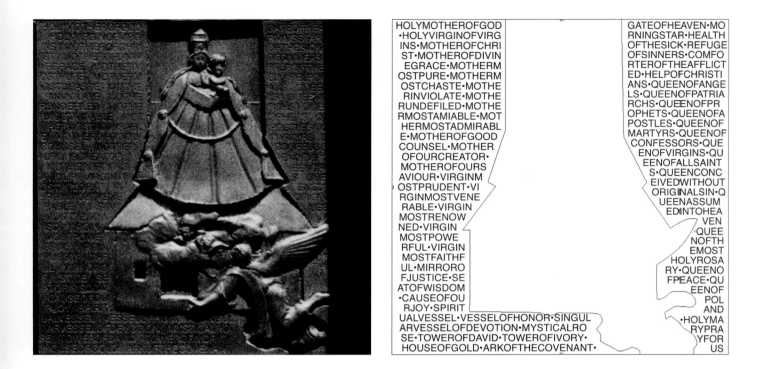

HOLYMOTHEROFGOD·HOLYVIRGINOFVIRGINS·MOTHEROFCHRIST·MOTHEROFDIVINEGRACE·MOTHERMOSTPURE·MOTHERMOSTCHASTE·MOTHERINVIOLATE·MOTHERUNDEFILED·MOTHERMOSTAMIABLE·MOTHERMOSTADMIRABLE·MOTHEROFGOODCOUNSEL·MOTHEROFOURCREATOR·MOTHEROFOURSAVIOUR·VIRGINMOSTPRUDENT·VIRGINMOSTVENERABLE·VIRGINMOSTRENOWNED·VIRGINMOSTPOWERFUL·VIRGINMOSTFAITHFUL·MIRROROFJUSTICE·SEATOFWISDOM·CAUSEOFOURJOY·SPIRITUALVESSEL·VESSELOFHONOR·SINGULARVESSELOFDEVOTION·MYSTICALROSE·TOWEROFDAVID·TOWEROFIVORY·HOUSEOFGOLD·ARKOFTHECOVENANT·

GATEOFHEAVEN·MORNINGSTAR·HEALTHOFTHESICK·REFUGEOFSINNERS·COMFORTEROFTHEAFFLICTED·HELPOFCHRISTIANS·QUEENOFANGELS·QUEENOFPATRIARCHS·QUEENOFPROPHETS·QUEENOFAPOSTLES·QUEENOFMARTYRS·QUEENOFCONFESSORS·QUEENOFVIRGINS·QUEENOFALLSAINTS·QUEENCONCEIVEDWITHOUTORIGINALSIN·QUEENASSUMEDINTOHEAVEN·QUEENOFTHEMOSTHOLYROSARY·QUEENOFPEACE·QUEENOFPOLAND·HOLYMARYPRAYFORUS

**Virgin of Loreto
with the Litany of Loreto**

THE INNER DOORS: UPPER REGISTER

At the center of the great doors of the cathedral of Our Lady of the Angels—halfway up when you read from the bottom, halfway down when you read from the top—are what might be called "images of encounter": Old World images of Mary that crossed to the New World and were changed by what they met. Graham chose these images for several reasons but principally to suggest that the story of Mary through the centuries has been, first, a story of migration and, second, a story of fusion or syncretism.

Few images can be more vividly appropriate to illustrate the migration of religion than that of the House of Loreto, Loreto being the place in Italy to which, according to medieval legend, angels transported Mary's house from Nazareth. The flight of the Holy House would eventually become the subject for a great painting by Tiepolo, but the Virgin of Loreto (above) herself is suggestive on another count, for her face is black. Her darkness may be an artistic enactment of a line from the Old Testament Song of Songs (1:5) traditionally interpreted as a reference to her: "I am dark, and I am beautiful, O Daughters of Jerusalem." But when her darkness is linked to the legend of the flying house (at her feet, above), it may seem to bespeak a nascent medieval awareness that Miriam of Nazareth was not a European.

Other "black Madonnas" in Europe, including the Virgin of Montserrat (right)—originally from Catalonia, now celebrated in the Caribbean—crossed to the Americas. The most famous of all the European black Madonnas, however, is probably the Black Madonna of Czestochowa, also called Queen of Poland. That title is among the last words of the printed excerpt from the Litany of Loreto that forms a backdrop for

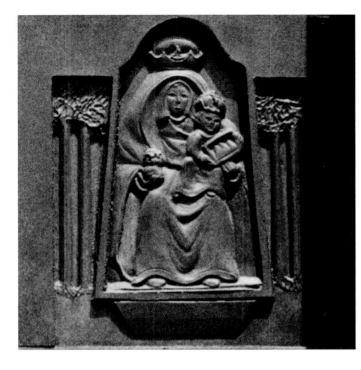

Virgin of Montserrat

the image of the Virgin of Loreto.[9] In this incantatory prayer, Mary is addressed in succession by all of her often poetic titles: Mystical Rose, Tower of David, Tower of Ivory, House of Gold, Ark of the Covenant, Gate of Heaven, Morning Star, Health of the Sick, Refuge of Sinners, and so forth. After each title, the faithful recite "Pray for us." Catholic tradition understands Mary to be a mediator, an intercessor, a kind of friend in the heavenly court. The figure in the tympanum, seen as she who hears this rhythmic "Pray for us...Pray for us...Pray for us," becomes a supplicant before the heavenly throne, her outstretched arms acquiring yet another meaning.

In North America, of course, a far more famous black Madonna is the beloved Virgin of Guadalupe, nicknamed *La Morenita,* "The Darky," an image as tightly bound to Mexican patriotism as the Queen of Poland is to Polish patriotism. *La Virgen de Guadalupe* appears twice in Graham's composition—first, as herself in the sunburst-framed image (see page 32) familiar not only to everyone in Mexico but to nearly everyone in Southern California; second, by the representation of an *ex voto* (see page 33) left by a mother whose prayers to *La Morenita* for her sick *niño* were answered. Graham includes not just the picture she left but also her Spanish testimony to the Virgin in period handwriting.

The legend of the Virgin of Guadalupe opens in 1531 when an Indian catechumen traveling through the mountains near Tepeyac, above Tenochtitlán (now Mexico City), heard a flock of birds singing with unearthly sweetness. Suddenly, atop the mountain he was climbing, he saw a lady whose radiant beauty overwhelmed him. Her raiment shone like the sun. Above her arched a rainbow in whose glow the cactus and other mountain plants around him were transformed into gorgeous flowers. The beautiful lady solemnly charged him to have a church built in her honor. Alas, when the Indian, Juan Diego by name, brought the lady's commission before the local bishop, the skeptical prelate would hear nothing of it. Poor Juan Diego was sent on his way. But the lady appeared to him again, and this time she promised him a miracle that would convince all.

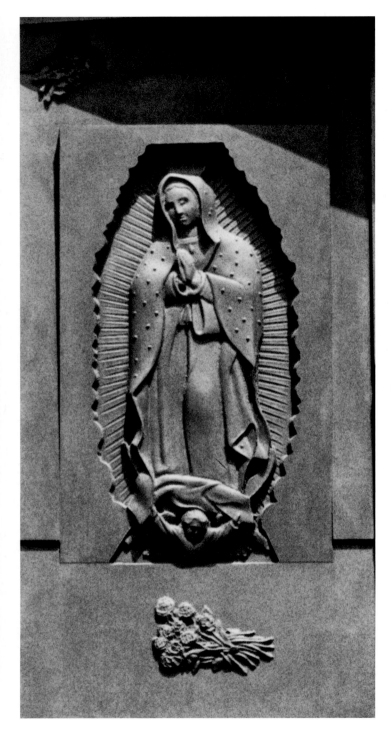

Virgin of Guadalupe

In December, when no flowers bloom, he was to climb back up the mountain to the spot she would indicate and there gather the thornless roses that, she assured him, he would find awaiting him. Juan Diego did as he was instructed, found the roses, and brought them to the beautiful lady, who wrapped them in his cloak and told him to bring them to his bishop as a sign. Juan Diego again did as he was told. This time, when he opened his cloak before the bishop, he found to his amazement that the lady had worked a second miracle. There were the roses, yes, but there was in addition an image of the lady herself, clothed in the sun and imprinted on Juan Diego's humble hemp-cloth cloak. Seeing this miraculous image, the bishop fell to his knees. When he arose, he explained to the wondering Juan Diego who the beautiful lady was: She was Mary, the Virgin Mother of God himself.

In due course, the bishop did as Mary wished, building a shrine in her honor, in which was housed the miraculous image that she had vouchsafed to the humble Indian. More than 450 years have passed since that legendary first shrine was built to the Virgin of Guadalupe. In 1979 Pope John Paul II visited the great circular basilica in the Tlaxcala district of Mexico City where the image is now enshrined. In 1999 he named her patroness of the Americas, North and South. No manifestation of the Virgin has ever been awarded greater honor; and after St. Peter's Basilica in Rome, the Basilica of Our Lady of Guadalupe has become the most visited pilgrimage site in the Christian world.

In more recent decades, scholars of pre-Columbian religion have added fascinating footnotes to the touching legend of Juan Diego and the miraculous image on his cloak. Their attention has been drawn by a constellation of features in this legend and

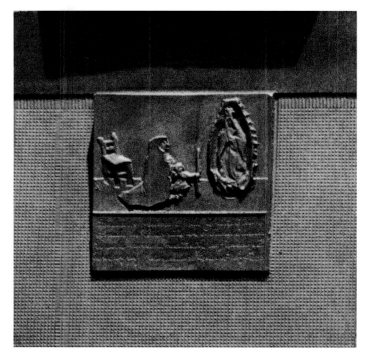

Hallandose gravemente malo el niño José M! Aguilar de Bronquitis su Mama Juana Urriola invoco a nuestra Sª de Guadalupe de Tierra negra, y quedo bueno Celaya Mayo de 1885

Ex voto to the Virgin of Guadalupe with inscription

image not known in any European Marian apparition but comfortably at home in the Aztec cult of the mountain goddess Tonantzin. Among these are numbered the mountain, Tepeyac; the number of rays in the sunburst that frames the Virgin; the number of stars in her mantle itself, and various details in the story of her apparition to Juan Diego. Some see the story as the Aztecs' joke on the Spaniards—the Aztec Tonantzin, disguised as Mary, being smuggled into the Spaniards' Catholicism. Others see it as the cultural imperialism of Spain at its worst—the arrogant bishop foisting his Marian interpretation on an Indian who, left to his own devices, would have "correctly" identified the beautiful lady as Tonantzin. As D. A. Brading points out in *Mexican Phoenix* (p. 93), even the name *Guadalupe* is ambivalent. Does it refer to Guadalupe, Spain, a town in the province of Extremadura, not far from where Cortés the Conquistador was born? There did exist a well-established Spanish cult of Our Lady of Guadalupe. Or did Juan Diego name the beautiful lady in his native Aztec tongue, Nahuatl, as *tequatlauopeuh,* meaning "originating in the mountain" or "of the mountain"—thus, in effect, "Our Lady of the Mountain"? Years after Guadalupe became the established name, Indians were still heard to mispronounce it *Tequatalope.*

Robert Graham, it seems safe to say, takes no position in this dispute but like Octavio Paz is powerfully drawn to the syncretistic result. Paz has written:

> Mother of gods and men, of stars and ants, of maize and maguey, Tonantzin/Guadalupe was the answer of the imagination to the state of orphanage in which the conquest left the Indians. Their priests exterminated, and their idols destroyed, their links with the past and the supernatural broken, the Indians took refuge in the skirts of Tonantzin/Guadalupe, the skirts of the mother mountain, skirts of the water mother. The ambigu-

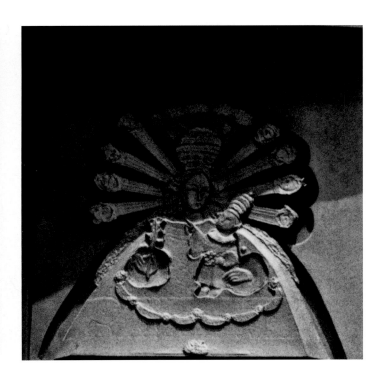

Virgin of the Rosary of Pomata

ous situations of New Spain produced a similar reaction: the creoles searched for their true mother in the womb of Tonantzin/Guadalupe, a natural and supernatural mother, made from American earth and European theology. [10]

As an artist Graham is drawn even more powerfully to a less well-known but art-historically far more important example of the same syncretistic phenomenon that produced the Guadalupe. Around the time he began work on the great doors, Graham read Carol Damian's *The Virgin of the Andes: Art and Ritual in Colonial Cuzco*. This intriguing and elegant book documents and analyzes the work of the School of Cuzco, a group of native Peruvian and mestizo (Peruvian-Spanish) artists who rebelled against the dictates of the Spanish guild system and emerged as an independent art guild in 1688. The School of Cuzco, the first indigenous organization of artists in the New World, flourished until around 1800. Initially dependent on the tastes and demands of their Spanish patrons, or influenced by the styles of certain Spanish artists to whom they were exposed, Cuzco artists went on to develop characteristic elements that merged Italian Renaissance, Mannerist, Flemish and Spanish Baroque traditions with indigenous styles (Damian, p. 9).

In this multiple merger, the fusion that most fascinated Graham began with the fact that the Inca earth mother, Pachamama, rather than the goddess of a sacred mountain, was a goddess who simply *was* a sacred mountain:

> Thus, everything on earth and in it "is," or is sustained by, Pachamama. She does not have concrete form as a human deity. Her force is contained within the earth, a rock in the field, a river stream, a mountain" (Damian, p. 51).

Among the innumerable manifestations of Pachamama's power, however, the mountain was iconographically paramount in the Incas' own predominantly sculptural tradition. But could the Virgin Mary, as she became iconographically confused with Pachamama, be represented as a mountain?

The answer, amazingly enough, was yes. As Spanish-trained Inca artists turned to painting, Mary could be represented as a mountain by making her gown from waist to ankle describe an ever larger, ever more conical shape and by raising her waist ever

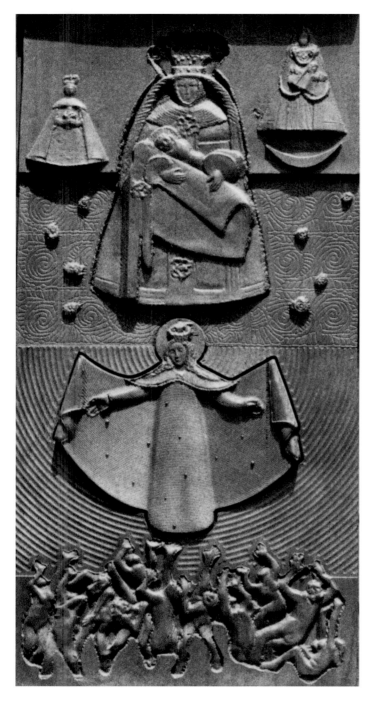

Virgin of the Candlestick with Virgins of Belén

Virgin of Mercy

higher until at length her figure evolved into a head atop a gigantic, mountain-shaped skirt. And this was just the most striking figure of her iconographic transformation. Reinforcing her "mountainization," the plants and flowers embroidered on her gown—all of them native Andean species associated with Pachamama's bounteous fertility—could be rendered with such naturalistic accuracy that they seemed to be literally growing on her sloping flanks. In the most amazing (though not necessarily the most successful) example of this evolution, "The Virgin Mary of the Mountain of Potasiama," the Virgin's head and hands protrude from the mountainside as if they were bushes growing on a hillside. The summit of the mountain rises *above* the Virgin's head, and on the lower slopes of the mountain, one sees pilgrims climbing toward her face as if it toward a mountain sanctuary.

One of the favorite images of the School of Cuzco is the Virgin of the Rosary of Pomata (an Andean village where the Virgin was believed to have made a miraculous appearance). In this image (page 34), both the Virgin and her infant Son wear, remarkably, the brilliantly colored feather headdresses associated with Inca royalty and Inca deities. Mary's face is further framed by an enormous circle of tiny winged cherubs, the holy feathers of Europe blending in with the holy feathers of America. This vertical halo radiates golden light like the disc of the sun setting behind her mountainous figure. The panel above combines three other images from the School of Cuzco: the Virgin of the Candlestick (minus the actual candlestick) and two different versions of the Virgin of Belén (another Andean village associated with a Marian apparition), all exemplifying the same mountainizing style.

Among Spain's contributions to the School of Cuzco, by no means the least was

the master-image behind the syncretism that produced this school—namely, the image of the Immaculate Conception (right). The Immaculate Conception of Mary, not to be confused with the Virgin Birth of Jesus, is the Catholic dogma according to which Mary alone, among all human beings, escaped the curse that God spoke against Adam and Eve after they ate the forbidden fruit in the Garden of Eden. That sin was not just the personal downfall of the first couple, it was "the fall of man," the heritable "original sin" by which all human beings—except Mary, who was spared, because of the role she was to play—are born morally flawed. The fall of man marked the rise of Satan, the serpent who seduced Eve into sin and has "bedeviled" human history ever since. Mary, born as a sinless Second Eve, was destined to inflict upon Satan at the end of time his final, definitive defeat. It is because of her Immaculate Conception, guaranteeing immunity against Satan, that Mary is able to accept the more militaristic vocation that leads to the title "Apocalyptic Virgin."

In pre-modern Catholic tradition, the verse in Genesis (3:15) that reads

> I will put enmity between you [the Serpent] and the woman,
> and between your seed and her seed.
> He shall bruise your head,
> and you shall bruise his heel

was translated, following a mistake in the Latin translation,

> *She* shall bruise your head,
> and you shall bruise *her* heel.

Spanish theology—like all Catholic theology until modern times—heard in this verse a prediction that Mary would eventually have to do battle with Satan. What sort of battle would it be, and when would it take place? The same theology found the answer in the Book of Revelation, which is also known as the Apocalypse. When the fifth of the famous "Seven Seals" is opened,

> ...a great portent appeared in heaven, a woman clothed with the sun, with the moon under her feet, and on her head a crown of twelve stars; she was with child and she cried out in her pangs of birth, in anguish for delivery. And another portent appeared in heaven; behold, a great red serpent, with seven heads and ten horns, and seven diadems upon his heads. His tail swept down a third of the stars of heaven, and cast them to the

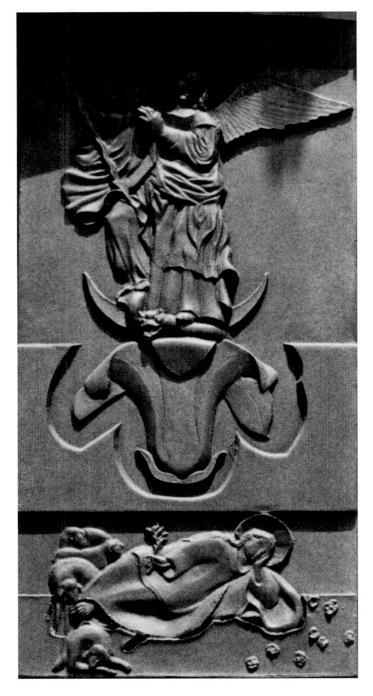

**Apocalyptic Virgin/
Immaculate Conception**

Divine Shepherdess

earth. And the serpent stood before the woman who was about to bear a child, that he might devour her child when she brought it forth. And she brought forth a male child....

And when the serpent saw that he had been thrown down to the earth, he pursued the woman who had born the male child. But the woman was given the two wings of the great eagle that she might fly from the serpent into the wilderness, to the place where she is to be nourished for a time, and times, and half a time. (Revelations 12:1-5, 13-14)

Graham's embattled Apocalyptic Virgin (left, above)—also known as the Virgin of the Fifth Seal—includes the rarely portrayed wings of this vivid, not to say lurid, passage. The cosmic war rages on through various battles; but to make a long and tangled story short, the serpent, Satan, loses, and the woman, Mary, contributes to his defeat. This explains why classic Spanish paintings of the Immaculate Conception by Francisco de Zurbarán and Bartolomé Esteban Murillo, in which the Virgin is mild and girlish, nonetheless show her standing on the moon of Revelation 12. This same association explains as well why the Immaculate Conception could be construed as a warrior woman whose image the Spaniards could and did raise confidently aloft as a battle standard. Finally, this same conjunction explains why after the Spaniards with their "Apocalyptic Virgin" defeated the Incas, the Incas inferred that henceforth they too should seek her protection. And since, like Mary, Pachamama was associated with the moon, a process of fusion was set in motion that would have the School of Cuzco among its eventual consequences.

Born Roberto Carlos Peña Graham in Mexico City to a Mexican father and an American mother, Robert Graham may be said to have multicultural syncretism of this sort engraved on his escutcheon. He is, by descent, a man not altogether unlike the woman

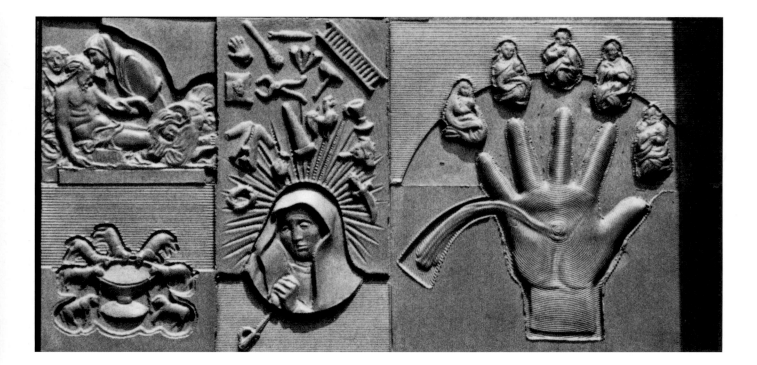

Left above: **Deposition or *Pietá***

Left below: **Chalice with Sheep**

Middle: ***Mater Dolorosa***

Right: ***La Mano Todopoderosa,* "The All-Powerful Hand"**

who was his model for Our Lady of *Los Angeles.* But his personal story happens to coincide with a major transformation of the Roman Catholic Church in North America. In the Church of Los Angeles the Hispanic population is heavily Mexican, but in New York the corresponding population is heavily Puerto Rican. Partly, at least, for that reason that Graham includes a carving of *La Mano Todopoderosa,* "The All-Powerful Hand," (above, right) in his doors.

This folk icon—popular in Puerto Rico, though the model for Graham's version was Mexican—shows the child Jesus standing on the middle finger, Mary on the fourth finger, Joseph on the index finger, and Mary's parents (Joachim and Anna, according to post-biblical tradition) on the remaining fingers. The hand itself is the nail-pierced hand of the crucified Christ from which blood is shown spurting. The blood is "aimed" at a chalice from which sheep are shown drinking (above, lower left). The image combines Gospel references in which Jesus promises, as the Good Shepherd, to feed his sheep and in which he tells his followers, the sheep of his flock, "my flesh is food indeed, and my blood is drink indeed" (John 6:55). This is a Marian image only by inclusion; obviously, its principal subject matter is the redemptive suffering of Christ. Graham was struck by the contrast between, on the one hand, Aztec fascination, during the colonial period, with Spanish Catholic imagery of suffering and blood and, on the other hand, Inca repugnance toward that imagery and preference for a Virgin who was in the Andes far less Our Lady of Sorrows than she was Our Lady of the Flowers. Graham's point in including both is that either may be an entry point to the complex reality that itself includes both.

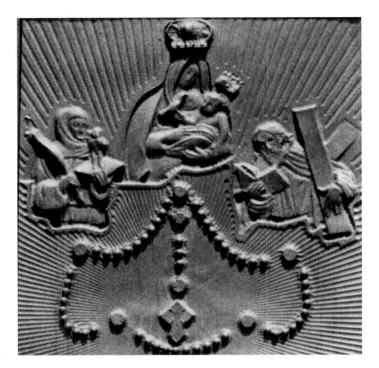

**Virgin of the Rosary
of Chichinquira**

Midway between folk art like the *Mano* and high art like the best work of the School of Cuzco is the Colombian Virgin of the Rosary of Chichinquira (left), in which Mary is flanked by St. Anthony of Padua on her right and St. Andrew on her left. The folk-art effect of this painting—extant in many versions—owes to the fact that rosary of the title is invariably a confection of gold and gems not painted on the canvas but sewn to it. Graham evokes the Virgin of Chichinquira but substitutes his mother's rosary for the more ornamental Colombian original.

If the style of the upper register of the inner doors is New World syncretism, their dominant theme, despite the flowers of Cuzco, is of sorrow, danger, and refuge, particularly in the images that remain to be mentioned. This is the theme that links the Divine Shepherdess (see page 37) resting in the field with her sheep,[11] to the Mother of Mercy ransoming souls from Purgatory that she may gather them under her cloak as a hen gathers her chicks under her wings (see page 35). Mary does this because she is *Mater Dolorosa*, the Mother of Sorrows (page 38), and she understands. When Joseph and she brought the infant Jesus to the Temple in Jerusalem, the prophet Simeon blessed them but warned:

> Behold, this child is set for the fall
> and rise of many in Israel.
> and for a sign of contradiction.
> And a sword will pierce your own heart as well,
> that the thoughts of many other hearts may be revealed. (Luke 2:34-35)

The panel includes that piercing sword as well as images of the cruel implements of crucifixion. The worst of the traditional Seven Sorrows of Mary would come when Christ's body was taken down from the cross (page 38) and she who had once cradled his infant body on her lap cradled his adult corpse in the same way. Tradition calls this oft-portrayed scene by its Italian title, *Pietá,* "Devotion" (page 38).

The suffering of children, the sorrow of mothers, the outrage of punishment when no crime has been committed—these are not Christian but universal human

themes. But Christianity does as every durable religious tradition must do. In the middle region between revelation and instinct, it gives the universal a particular form, and this particularization of the universal is just what Robert Graham has placed in the middle of his Great Bronze Doors.

CONCLUSION: CAN SPACE BE SACRED?

Graham's doors open inward on an ambulatory leading to a great hall where the Catholic Christians of Los Angeles will assemble again and again, in the years to come, to sanctify space by endlessly enacting and re-enacting the ritual drama that has held the Church together for two millennia. Strictly speaking, there is no such thing as sacred space. King Solomon said as much at the dedication of the Temple of Jerusalem:

> Will God really live with people on earth? Why, the heavens and the heavens of the heavens cannot contain you! How much less this temple built by me! Even so, listen favorably to the prayer and entreaty of your servant, Yahweh my God; listen to the cry and to the prayer which your servant makes to you: Day and night, may your eyes watch over this temple, over this place in which you have promised to put your name. Listen to the prayer which your servant offers in this place. Listen to the entreaties of your servant and of your people Israel; whenever they pray in this place, listen from the place where you reside in heaven; and when you hear, forgive. (2 Chronicles 6:18-21, New Jerusalem Bible translation)

Reflecting texts like this one from 2 Chronicles, contemporary Catholic theology tends to understand a cathedral or any church edifice less as "God's house" than as a place where God's people assemble to worship him. It is he alone who is holy. Space can be made holy only by association with him. But by the multiplication of such associations, a once-secular space may accrue, over time, a borrowed holiness. Robert Graham's bronze doors, embracing a multitude of sacred associations, proclaim holiness-by-association as their aspiration. But the same chastened rather than arrogant aspiration is shared by all those who have sacrificed to build this new temple to God in Los Angeles, trusting, as Solomon did, that when they pray in this place, God will listen from where he resides in heaven and that when he listens, he will forgive.

NOTES

1. All Bible translations are by Jack Miles except where otherwise indicated.

2. From, "The Leaden Echo and the Golden Echo," with apologies for the change of pronoun. Hopkins's heaven is a place

> Where whatever's prized and passes of us, everything that's fresh
>
> And fast flying of us, seems to us sweet of us and swiftly away
>
> With, done away with, undone,
>
> Undone, done with, soon done with, and yet dearly and dangerously sweet
>
> Of us, the wimpled-water-dimpled, not-by-morning-matchèd face,
>
> The flower of beauty, fleece of beauty, too to apt to, ah! to fleet,
>
> Never fleets móre, fastened with the tenderest truth
>
> To its own best being and its loveliness of youth: It is an everlastingness of, O it is an all youth!

3. Light could not be the design element that it is in Graham's portrayal of Mary if the placement of the doors within the cathedral did not permit light to fall directly upon her. Nor would the central figure of the Virgin have the impact described here if visitors to the cathedral did not have a direct view of her as they approached its entrance. In architect Rafael Moneo's original design, light did not fall directly on the doors, and the doors faced diagonally across the cathedral plaza in such a way that they were not in the line of sight for arriving visitors.

These matters, potentially at issue between Moneo and Graham, were resolved in Graham's favor in a memo dated December 1, 1998, from Cardinal Mahony, which stated, in part, that the cathedral—of which the boast had been that it contained not one right angle—would now have at least one:

> **Our main and principal concern is how the worshippers move through the Bronze Doors into the ambulatory**. We want this movement to be inviting and natural. Consequently, the Bronze Doors will be at a right angle to the south wall of the Cathedral so that the Doors face along the south colonnade sight line, rather than at an angle facing the northeast sector of the Plaza....
>
> **We desire the maximum amount of natural light falling upon the Bronze Doors, and no structural hindrances should impede that light.** I am very pleased that we will now have maximum light available through the south opening in the wall and structure, as well as the light coming from directly overhead.
>
> **The porch canopy will extend a maximum of two (2) feet from the top of the Bronze Door structure, giving us a maximum of six (6) feet overhang from the inner Door structure to the outer Door structure**. This decision guarantees that the maximum amount of natural light will now flood over the doors throughout the day in differing degrees, angles, and intensity—creating interesting light effects upon the Doors.

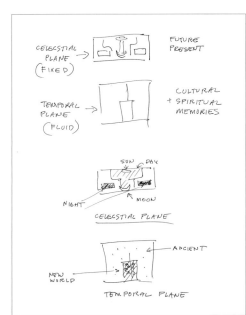

Drawing attached to a letter from Robert Graham to Father Vosko, June 29, 1999

4. In an early model, the Virgin wore sandals and long sleeves; but to the consternation of some, both had disappeared when a scale model of the doors was displayed at a fund-raising dinner on May 24, 1999. A week later, Cardinal Mahony wrote Graham (June 2, 1999):

> ...some cautions are being raised by some members of our Cathedral Advisory Board over the final form and appearance of the statue.... For example, it appears that the woman in the full model has sleeves and sandals. But the statue depicts otherwise. Some believe that the portrayal of Our Lady of the Angels is that of a woman now assumed into Heaven and with a more saintly look, such as at least a Madonna-like head covering.

Though the Cardinal conceded that "some of their issues are ones which I believe need to be revisited as well," he stopped short of actively endorsing the reservations of the unnamed members of the Advisory Board. Graham directed his reply (June 29, 1999) to Reverend Richard S. Vosko, who served as artistic consultant on the cathedral project to the Board and to Graham alike:

Father Vosko:
I believe artists are blessed with power to create images that sometimes may be alarming or unfamiliar. But in time, they become perceived as a continuum of a visual language that refreshes human experience for each succeeding generation.

Some thoughts in no particular order:

- Concept of garments in sacred images always follows cultural and geographical conventions of their time.
- Garments of Our Lady of the Angels reflect current ideas of clothing of the coming 21st Century:
 - warm climate
 - utter simplicity in garments
 - head covering not relevant to current dogma
- Purity of metaphorical concept (see drawing above).

More thoughts on Our Lady of the Angels:

- Metaphorical as opposed to literal
- Crowned with the sun
- Standing on the moon
- Symbolic power in New World of the braid
- Arms bare & pure and feet without need for adornment or protection, such as sandals, crowns, rings, sleeves

> The garment is completely comprehensible in its structural logic. Mystical in its impossible lack of perturbance, such as wrinkles and folds in its wearing (impossibly starched and serene, much like an apparition). In depiction of Our Lady as the Queen of Angels, Her grandeur is in its simplicity in context with the heavenly plane of the tympanum. This I feel would be debased by adding ersatz regal trappings or other "fancy" ornaments to Her garments.

Father Vosko informed Graham on July 29, 1999, that his suggestion to the Cardinal had been to "wait until September when the Arts and Furnishings Committee and the Cardinal can come to your studio to see what you are proposing." This visit occurred on November 22, 1999, though without the Cardinal, and was an almost unqualified triumph for Graham. A December 3, 1999, memo to him from the office of Monsignor Kevin Kostelnik, pastor of the cathedral parish, reported enthusiastic comments, particularly from the women on the committee. The one remaining skeptic, a man, was quoted in the last line of the memo: "I could learn to live with it."

In Graham's studio itself, the controversy over veil, sleeves, and sandals created a smaller stir than did an earlier rejection by the Cardinal of Graham's plan to gesture toward venerable (if more or less Byzantine) iconographic tradition by placing at the center of his figure of Mary an infant Christ the King in upright position, naturalistically rendered as a plump, nude baby boy but with his right hand raised in blessing and his left holding a globe surmounted by the cross (see page 72). Cardinal Mahony objected to this image on the grounds that any inclusion of Jesus as infant or child in a portrayal of Our Lady of the Angels was an anachronism in salvation history. On February 4, 1999, the Cardinal wrote the sculptor:

> As I explained to you, the mystery of Our Lady of the Angels is really a post-Resurrection mystery, and Mary gained that title once she was assumed into Heaven. This follows the Resurrection of the Lord, and the coming of the Holy Spirit upon the apostles and the Church. Consequently, the statue of Our Lady of the Angels is best rendered without the presence in any form of the infant or child Jesus.

The absence of Jesus coupled to the youth of Mary in Graham's rendition results inevitably in additional stress on her innocence and therefore her Immaculate Conception. But the Immaculate Conception itself (see page 37) is an image with a surprising Joan-of-Arc potential: innocence and vigor fused in the Warrior Maiden. Interestingly, while these discussions were in progress, Graham read a passage from "How to Paint the Immaculate Conception of Our Lady" by the Spanish painter-theologian Francisco Pacheco (1564–1654) as quoted in Carol Damian's *The Virgin of the Andes*:

> Some say that the [Immaculate Conception of Our Lady] should be painted with the Christ Child in her arms...we side with those who paint Her without the Child. This is the more customary manner....(p. 36).

Graham's intention to portray Mary as a queen without any of the conventions of royalty was, at this early point, not entirely crystallized. Employing some of those very conventions to portray Christ as an infant King put Graham at odds with himself. Moreover, the Renaissance naturalism

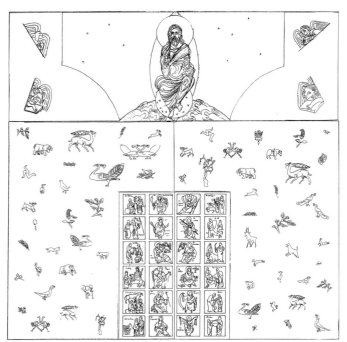

Sketch for the proposed doors, 1998

of the nude infant comported ill with the Byzantine or early medieval pose. Whether or not out of his own uneasiness with this image, Graham deferred to the Cardinal's theologically motivated objection with a lack of resistance that surprised some in the studio.

An issue in any case far more fateful than the inclusion or exclusion of Jesus was the inclusion or exclusion of Mary herself. Interestingly, the decision to place a statue or other representation of Mary in the portal to the cathedral did not originate with Rafael Moneo or even with Graham, but with Cardinal Mahony. Responding to guidance provided by the Rev. Richard S. Vosko to all candidates for the commission, Graham prepared a sketch (see left) showing Christ where Mary eventually would be. Vosko, in this early statement about the artistic program for the cathedral, had written: "The Great Door to the Cathedral is another reference to Jesus Christ as the gateway to salvation.... The Door is a powerful reminder that anything is possible in the Church – ('In Christ anything is possible')." At the start, no commemoration of Mary was programmed other than—in deference to Mexican Los Angeles—a small outdoor shrine to Our Lady of Guadalupe. The Cardinal, however, had become restless with this program.

On December 1, 1997, while Graham was still just one among several sculptors in contention, the Cardinal wrote him: "Since our new Cathedral bears the patronal title of Our Lady of the Angels, and since no architectural feature of the Cathedral depicts either Mary or the Angels, I am personally hoping that the Grand Doors will somehow portray that theme. Of course, we have not yet developed all of the artistic themes, and there may be other ways to highlight our Patroness. Personally, though, I am leaning toward having the south Grand Doors depict Our Lady of the Angels in some way—possibly using the panels for other images of Mary, such as Our Lady of Guadalupe."

The seventeenth-century warfare between the Protestants of the Reformation and the Catholics of the Counter-Reformation might almost be called a battle between Bibliolatry and Mariolatry. The Protestants exaggerated the importance of the Bible to the faith, while the Catholics exaggerated the importance of Mary. As modern biblical scholarship, with its largely Protestant roots, became the standard scholarship of the twentieth-century Catholic Church, there occurred a distinct swing among Catholic theologians away from earlier excesses in devotion to Mary. This is the correction that was reflected in Father Vosko's initial (and largely realized) artistic program for the cathedral, a program reflecting the near-certainty that Mary would never again loom as large in Catholic Christianity as she had done in the late Middle Ages. Nonetheless, a reaction has begun, even in Protestantism, to the aridity of historicist Bible scholarship; and it seems possible, even likely, that in Roman Catholicism the same reaction will foster a return to some of the highly

pictorial devotional practices of the Catholic past. Should that happen, the Cardinal's "personal leaning" toward Mary and Graham's ensuing engagement with the classic Catholic aesthetic (in a cathedral that, as a whole, concedes little or nothing to that aesthetic) may seem paradoxically far-sighted.

As the Blessed Mother, Mary was often shown in Medieval and Renaissance art with one breast bared to nurse her divine son. Graham once remarked to a visitor to his studio that Our Lady of *Los Angeles* was the first clothed female statue he had ever made. Had the times been ripe, he would readily have portrayed her nude to the waist to match the nude Christ of the Last Judgment in the Vatican's Sistine Chapel. Radicalizing the classic Catholic aesthetic in this way, such an image would have made headlines around the world—but probably not the right kind of headlines. The times were not ripe, in short, yet it may well be Graham's exceptional sensitivity to the female figure that won him this greatest commission of his career. Cardinal Mahony's desire that Mary be given a prominent place on the doors to the new cathedral played to Graham's surpassing strength as a sculptor. Intriguing as the rest of his concept for the doors may be, it is his Virgin—his Woman—who makes the strongest impression and whose face and form linger longest in the memory.

5. The abstract triangular perfection of the Virgin's skirt, which is heightened by its flawlessly vertical central crease, emerged after Graham removed the infant Christ the King from his composition in deference to Cardinal Mahony. The crease itself later brought, briefly, some disgruntled comments from the Advisory Board, but these died down quickly. It may be noted that among the features of the School of Cuzco that had come to fascinate Graham around the time of the Cardinal's intervention were, in the Virgin's costume, an artificial, "mountainous" triangularity of the skirt and an extremely high placement of the waist. Though Graham, unlike Peruvian painters, preserves perfect anatomical proportion in Mary's figure, he does emphasize her stately (eight-foot) height by giving her gown a strikingly high waistline. She becomes Queen of the Angels by becoming, to a point, Mount St. Mary.

6. To a point midway in his work on the doors, Graham planned to place two horizontal angels—wingless but flying—in niches flanking the Virgin on the tympanum; other niches there would contain symbolic objects connected with Marian devotion. In the end, Graham decided against including the angels anywhere on the doors. He did this for two reasons. Aesthetically, they disrupted the calm and broke the focus that he sought to create on the central figure. Conceptually, their absence and the double meaning of the city name Los Angeles created an intriguing possibility. As he put it in reply to a questioner, "*We* are the 'angels' for Our Lady of *Los Angeles*." It is not unlikely, however, since complete or near-complete sculptures of the two angels do exist (see page 107), that they will eventually find a home somewhere in the cathedral complex. The archdiocese, looking ahead to the anticipated five-hundred-year life of the cathedral, has never advertised it as a finished product. It is, instead, an ongoing project with, by design, a great deal of room for artistic expression, completion, and revision.

7. Quoted in D.A. Brading, *Mexican Phoenix, Our Lady of Guadalupe: Image and Tradition Across Five Centuries,* p. 97.

8. Graham's original program located these images on the outer doors as "ancient" and even pre-historical in contrast to the historical, explicitly Marian "New World" images of the inner doors. His final program reconceived the ancient images as threshold images, relocated them to the inner doors, and realized them in extremely high relief as if, indeed, they were so many square door-knobs. Their multiplicity is intended to suggest that just as Catholic artistic tradition offers the Catholic various entry points to Catholic religious experience (most Catholic visitors will recognize something on the upper panels of the inner doors, but none will recognize everything), so non-Christian tradition offers an infinity of entry points into religious experience more broadly conceived.

9. The inclusion of "Queen of Poland" was a small act of homage to the current pope, the Polish-born John Paul II, by Cardinal Mahony, who wrote Robert Graham on February 25, 2000: "I am hopeful that one of those small panels will feature Our Lady of Czestochowa, a very important patroness in Poland and among our Polish Catholic people.... Since our Holy Father, Pope John Paul II, is of Polish origin, and given the fact that the Cathedral is being built during his pontificate, it seems to me quite appropriate that we have some recognization of our Holy Father and his great love for Our Lady of Czestochowa."

10. Cited in D.A. Brading, *Mexican Phoenix, Our Lady of Guadalupe: Image and Tradition*, p.330.

11. Donna Pierce writes in *Cambios: The Spirit of Transformation in Spanish Colonial Art*:

> According to legend [Mary] appeared to a venerable monk,...Isidoro of Seville,...dressed as a shepherdess and accompanied by her flock. Urging Isidoro to honor her as the Divine Shepherdess, she vowed to assist him in his missionary efforts....

This image is unusual in that the Divine Shepherdess is shown reclining.... It may also be related to pastoral or allegorical scenes in secular painting of the era. The familiarity necessary to depict the Virgin Mary so casually may be a manifestation of the freedom inherent in the art of the New World (pp. 89–90).

BIBLIOGRAPHY

Brading, D. A. *Our Lady of Guadalupe: Image and Tradition Across Five Centuries.* New York: Cambridge University Press, 2002.

Cirlot, J. E. *A Dictionary of Symbols.* New York: Philosophical Library, 1971.

Clark, Kenneth. *Animals and Men, Their relationship as reflected in Western art from prehistory to the present day.* New York: William Morrow, 1977.

Cunneen, Sally. *In Search of Mary, The Woman and the Symbol.* New York: Ballantine Books, 1996.

Damian, Carol. *The Virgin of the Andes: Art and Ritual in Colonial Cuzco.* Miami Beach, Florida: Grassfield Press, 1995.

Ebertshauser, Caroline H., Herbert Haag, Joe H. Kirchberger, Dorothee Solle. *Mary: Art, Culture, and Religion through the Ages.* New York: Crossroad Publishing, 1997.

Oettinger, Marion, Jr. *El Alma del Pueblo, El arte popular de España y las Américas.* San Antonio, Texas: San Antonio Museum of Art, 1997.

Palmers, Gabrielle and Donna Pierce. *Cambios: The Spirit of Transformation in Spanish Colonial Art.* Albuquerque, New Mexico: Santa Barbara Museum of Art in cooperation with University of New Mexico Press, 1992.

Pelikan, Jaroslav. *Mary Through the Centuries: Her Place in the History of Culture.* New Haven, Connecticut, and London: Yale University Press, 1996.

Ancient symbols

1. Ibis
2. Celtic Serpents
3. Energy (soul)
4. Rooster
5. Griffin
6. Stag
7. Lion
8. Bull (St. Luke the Evangelist)
9. Fish
10. Croatian Cross
11. Water
12. Trefoil (Celtic Trinity)
13. Hand of God
14. Chumash Condor
15. Lamb
16. Dog
17. Goose
18. Peacock Barge
19. Eagle (St. John the Evangelist)
20. Peacock
21. Hand (listening symbol)
22. Sicilian Legs (regeneration symbol)
23. I Ching/ Tai Chi
24. Celtic Monster
25. Southwest Indian Flying Serpent
26. Griffin
27. Dove
28. Falling Man
29. Chinese/Japanese Heaven Symbol
30. Bull
31. Samoan Kava Bowl
32. Raven Eating Man's Liver
33. Chumash Man
34. Chinese Turtle
35. Bee
36. Tree of Jesse
37. Pair of Ostriches
38. Serpent/Dragon
39. Foot
40. Dolphin

Manifestations of the Virgin

Virgin of Pomata. Pomata is a village in the Andes. The image is one produced by the late-colonial School of Cuzco. Note the feathered Inca headdress at the top; flanking the headdress, the thick rays of the vertical halo, each of which ends in a tiny, winged cherub's head; and the rounded, "mountainous" treatment of the Virgin's skirts, suggesting the Inca mountain goddess Pachamama.

Ex Voto to Virgin of Guadalupe. An *ex voto* (the Latin phrase means "out of a vow") is an offering, not infrequently a picture, that a devotee vows to leave at a shrine in gratitude and homage if a favor is granted. This ex voto shows a mother with her child kneeling before the image of the Virgin of Guadalupe. The handwritten text below describes the healing of the child vouchsafed by the Virgin.

Apocalyptic Virgin/Immaculate Conception. In this extremely flamboyant image, the Virgin is shown with the mighty wings of Revelations 12, crushing a serpent, representing Satan, between her foot and the huge lily seen at the bottom of the image. The lily is a symbol of her own sinlessness, the source of her invincibility.

Divine Shepherdess. The Virgin once appeared to a pious Spanish monk garbed as a shepherdess. This image shows the "Divine Shepherdess," as she came to be known, reclining in the field with four of her sheep.

Virgin of Guadalupe. An angel supports the crescent moon on which the Virgin stands framed by the rays of the sun. Above and below the image are three bouquets of thornless roses, a beloved part of the legend of her appearance to the Indian peasant, Juan Diego.

Virgin of the Cave. The Spanish knew of an image of the Virgin that had been buried accidentally in a cave, was miraculously recovered, and had miraculous powers. The image became particularly popular in the Spanish Caribbean.

Virgin of Montserrat. Montserrat, Catalonia, is home to the most authentically black of the "Black Madonnas" of Europe; in this case, both mother and child are black.

Virgin of the Candlestick with Virgins of Belén. The smaller images are of the Virgin as she appeared in Belén (Bethlehem), Peru. The largest of the three shows a strikingly "mountainized" School of Cuzco Virgin holding a blanket over her arm, under a tightly wrapped infant Jesus.

Virgin of Mercy. Mary spreads her cloak protectively over the souls suffering in Purgatory and clamoring for her to intercede for them.

Virgin of the Rosary of Chichinquira (Colombia) flanked by St. Anthony and St. Andrew. St. Andrew, on the right, was crucified, according to legend, on an X-shaped gibbet. St. Anthony, called "the Christographer," is shown with a small image of Christ standing on a book. This often reproduced image was traditionally adorned by an actual rosary. The version here includes Robert Graham's mother's rosary.

Deposition or *Pietá*. Christ has just been taken down from the cross. Mary embraces him.

Chalice with Sheep. The chalice receives the blood spurting from the pierced hand of Christ on the far right. In a pantomime of the Eucharist, the sheep—representing devout Christians, the sheep of the Good Shepherd's flock—drink his blood.

Mater Dolorosa, **the Sorrowful Mother**, at the bottom of the panel; above, implements of the crucifixion of Christ.

La Mano Todopoderosa, **the All-Powerful Hand.** Members of the Holy Family stand on the five fingers; from left to right, Anna, Mary, Jesus, Joseph, Joachim. Anna and Joachim are Mary's parents, and Joseph and Mary are Jesus' guardian and his mother.

Virgin of Loreto with House of Loreto, borne by angels. As backdrop, excerpts from the Litany of Loreto, ending with (in homage to John Paul II) "Queen of Poland."

Virgin of the Cave

Virgin of Pomata

Apocalyptic Virgin/
Immaculate Conception

Ex Voto to Virgin of
Guadalupe

Divine Shepherdess

Virgin of Guadalupe

Virgin of
Montserrat

Pietá

Virgin of the
Candlestick with
Virgins of Belén

Virgin of the Rosary
of Chichinquira

Chalice
with
Sheep

*Mater
Dolorosa*

*La Mano
Todopoderosa with
Holy Family*

	1			4	
		2	3		
	5			8	
		6	7		
	9			12	
		10	11		

Virgin of Loreto
with Litany of
Loreto

Virgin of Mercy

	13			16		
		14	15			
	19			22		
17	18		20	21	23	24
	27			30		
25	26		28	29	31	32
	35			38		
33	34		36	37	39	40

Virgin of the Cave

Virgin of Pomata

Apocalyptic Virgin/
Immaculate Conception

Virgin of
Montserrat

Virgin of Guadalupe

Divine Shepherdess

Ex Voto to Virgin of
Guadalupe

Pietà

La Mano
Todopoderosa with
Holy Family

Mater
Dolorosa

Chalice
with
Sheep

Virgin of the Rosary
of Chichinquira

Virgin of the
Candlestick with
Virgins of Belén

		4			1	
			3	2		
		8			5	
			7	6		
		12			9	

Virgin of Loreto
with Litany of
Loreto

Virgin of Mercy

			11	10		
		16			13	
			15	14		
		22			19	
24	23		21	20	18	17
		30			27	
32	31		29	28	26	25
		38			35	
40	39		37	36	34	33

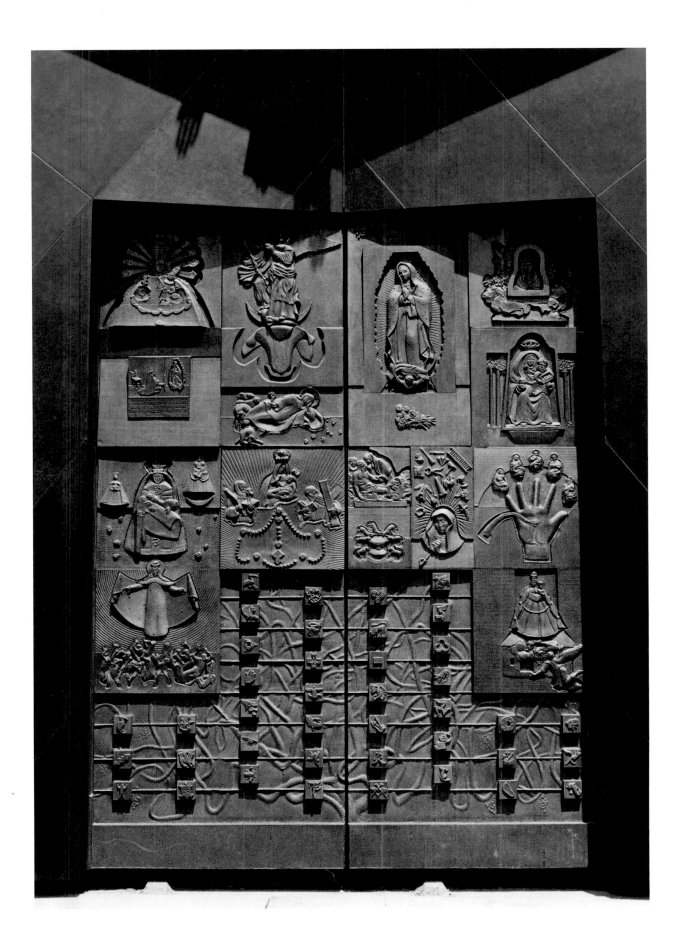

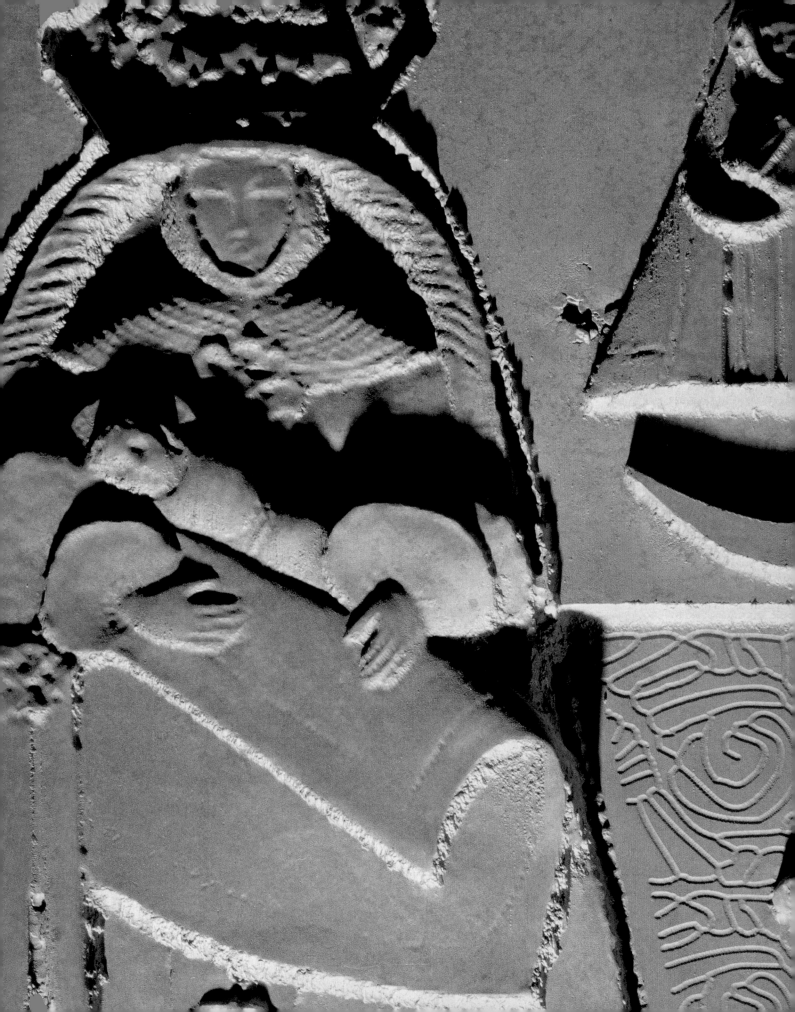

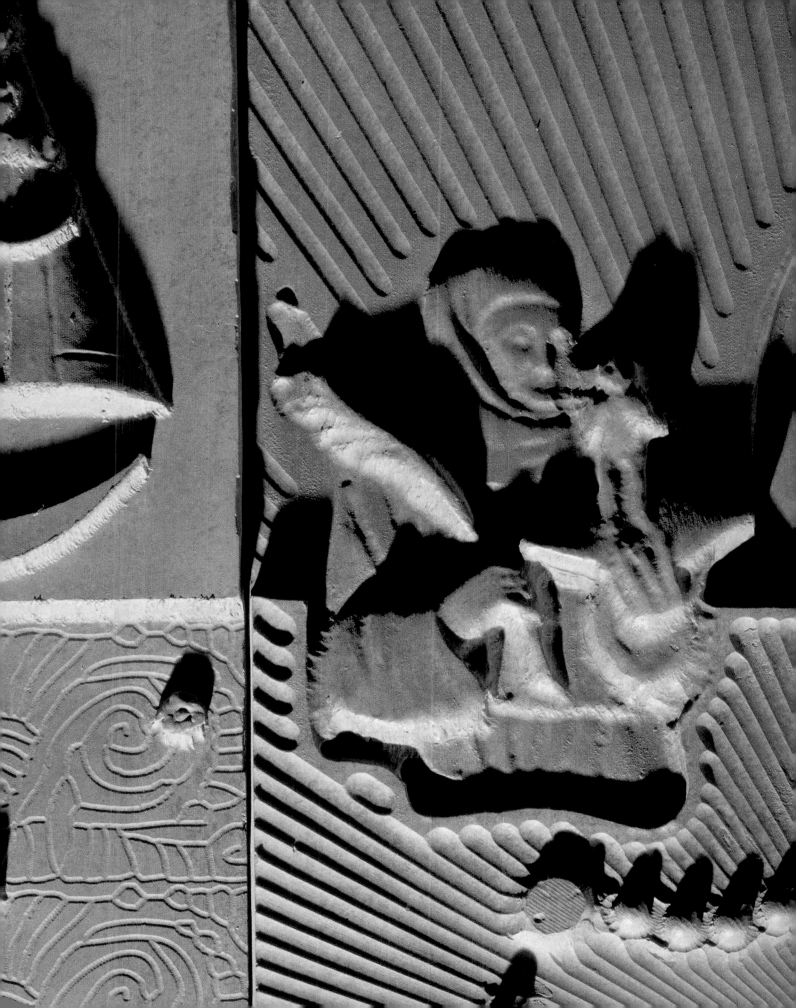

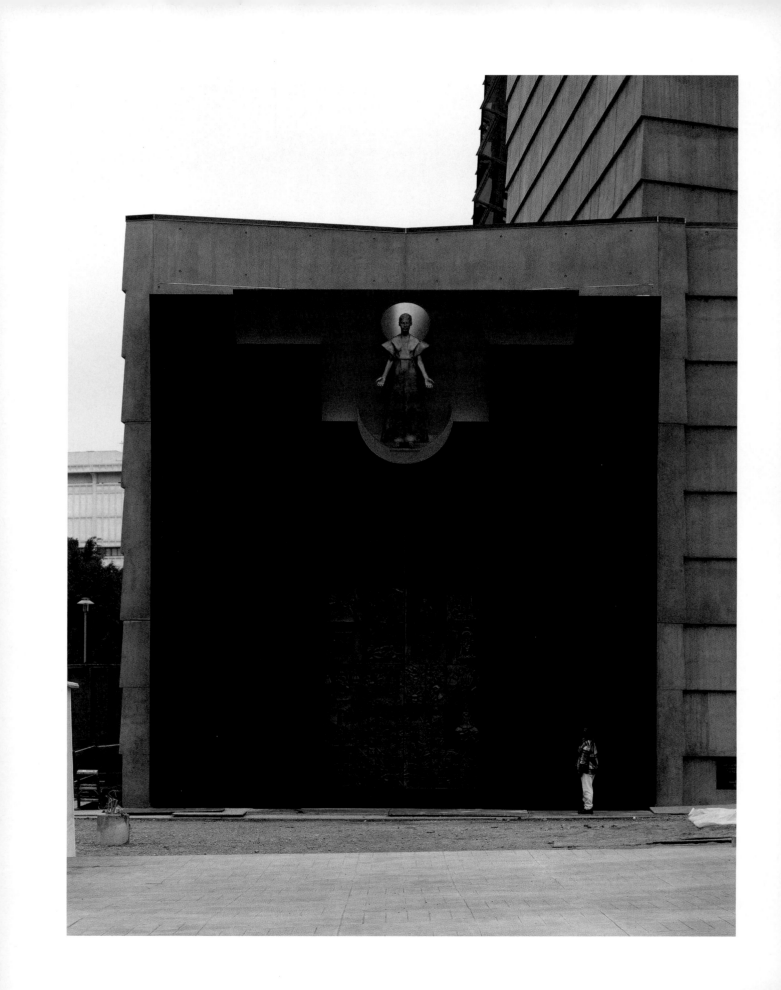

ROBERT GRAHAM'S BRONZE DOORS: A HISTORICAL PERSPECTIVE

by Peggy Fogelman

I N ROBERT GRAHAM'S BRONZE DOORS for the Cathedral of Our Lady of the Angels, material and meaning are so seamlessly wed, and their function as a portal from the everyday space of the outside world to the contemplative, devotional interior of a church is so well accomplished, that their creation may appear effortless. The very fact that the doors are made of bronze, however, implies centuries of tradition, highly skilled expertise, a long and multistaged collaborative process from conception to execution, countless hours of physical and mental labor, great expense, and the potential for numerous technical problems. From the perspective of the twenty-first century, with the casting of everything from decorative doorknobs to automobile parts commonplace, the choice of bronze as a material for monumental cathedral doors may seem obvious, and the technical challenges inherent in their production negligible.

This, however, is not the case. The doors' sheer size alone conveys the difficulties of realizing such a project. The large outer doors of the Cathedral of Our Lady of the Angels measure twenty feet high by fifteen feet wide and weigh seven tons each. The complexity of Graham's composition—which combines bronze casting, various assembly methods, and both relief decoration and sculpture in-the-round—and the fact that all the components work together to compose a harmonious whole is testament not only to the sculptor's creativity but to his ability to harness technological tradition to modern innovation. To understand why and how Graham undertook this project in bronze, and to appreciate the inventiveness of his approach to the bronze-making process, it is necessary, by way of introduction, to place his work within the context of history, technology, and taste.

< The *Great Bronze Doors*, 2002, Cathedral of Our Lady of the Angels

One might well ask, "Why bronze?" An alloy composed primarily of copper and tin, bronze has been used as a material for making ornamental sculptural works since the late fourth millennium B.C. Properties inherent to the metal, both physical and aesthetic, must have appealed to the earliest sculptors. Bronze can be polished to a high luster, enhanced by its natural golden surface. It can also be coated to achieve a rich variety of colors. Strong and durable, bronze can be worked in a variety of ways—hammered, chiseled, or melted and poured into a mold. This latter technique, called *casting*, became the most prevalent means of creating three-dimensional sculpture in bronze and continues to the present day. Bronze has always been an expensive material and, coupled with its fine art associations, imparts a sense of preciousness and tradition to sculpture made from it. Since historically bronze was also employed to make weapons and armor, its use for works of art, especially civic or religious monuments, suggested the power, security, and wealth of the society or the patron.

Graham began working in bronze fairly early in his career, when he moved from Northern California to travel through Europe for several years. He settled in Los Angeles in 1971, and began using techniques that had been perfected—first by the ancient Greeks and then by Renaissance sculptors—and perpetuated throughout the history of European art without substantial change. Traditionally, to make a bronze, an artist begins with a series of models (rougher preliminary models are also called sketches) in a soft inexpensive material such as clay, wax, or plaster. The sculptor develops his ideas for the piece through various stages of the modeling process, using fingers and tools to shape and refine the forms until he is satisfied. If the finished model is smaller or larger in size than the desired work in bronze, the artist must reproduce an enlarged or reduced version by transferring measurements from the original and proportionally increasing or decreasing them in the reproduction. Calipers or proportional compasses were used for this process until the nineteenth century, when more sophisticated mechanical instruments were introduced. Nevertheless, the creation of the full-size model required the help of numerous studio assistants whose skill at least partially determined the degree to which the subtler nuances of the artist's touch were maintained in the transfer to another scale.

In the technique known as *indirect lost-wax casting,* the artist takes molds from the

model and uses them to produce a wax replica, referred to as the *casting model*. The wax casting model, if hollow, is filled with a porous mixture of clay, sand, and/or plaster that can absorb extreme heat, and, whether hollow or not, is then fully encased in a similar material. When this large cocoonlike structure is placed in a kiln, the wax melts out, and molten metal is poured in to take the place of the "lost" wax; after the bronze has cooled, it is broken out of its encasement. Although it still requires detailed finishing and polishing, the resultant bronze theoretically replicates the casting model, which itself reproduced the artist's original model.

Casting a bronze, even today, is a difficult undertaking with numerous pitfalls. Taking molds from the full-scale model usually damages or even destroys it in the process, eliminating the possibility of reusing the model if mold-making is not successful. Warped or inaccurate molds will reproduce the same problems in the final bronze. Melting the metal (which reaches approximately 2000 degrees Fahrenheit), and pouring it into the mold, is both delicate and dangerous. Any trace of moisture can cause explosions, and variations in the alloy or temperature can result in cracks or flaws in the bronze. The larger the bronze, the greater is the potential for something to go wrong. Because it is lighter in weight than stone, has the tensile strength to prevent fracturing, and can withstand outdoor environmental conditions, bronze is a material ideally suited for church doors that are pulled and pushed, opened and closed, and battered by rain and snow. The commissioning of monumental bronze doors to define the entry into sacred space, however, presented technical challenges that, at various times in the history of art, made their production unfeasible.

Whereas doors were important in ancient Egypt and the Near East, both as temple portals and places of assembly, they were for the most part made of large wood planks, sometimes with decorated bronze bands, nails, and doorknockers. The Greeks had developed a method of casting bronze for large-scale projects, including hollow life-size statues, by the seventh century B.C., and the level of expertise and refinement they achieved was rarely equaled in later centuries. Few such Greek and Roman works survived, however, as they were frequently melted down to supply material for armaments in times of war and political upheaval. Nevertheless, several monuments, such as the Pantheon in Rome, a circular domed temple rebuilt by the Roman Emperor

Hadrian around A.D. 120 and later converted to a church, feature enormous bronze doors that survived intact. These imperial examples provided inspiration to artists of the Carolingian Renaissance (circa A.D. 800–900), who cast three pairs of doors at the Holy Roman Emperor Charlemagne's palatine chapel in his capital city of Aachen, now in Germany. Unlike the doors in ancient Rome, which were cast as separate bronze panels and then placed into a framework, or Italian examples in which the bronze relief panels were attached to a wooden core, Charlemagne's doors were cast in one piece, a true technical feat. As the Aachen portal demonstrates, the casting of monumental doors in bronze represented the forefront of technological endeavor in any society and marked the height of its industrial ambitions.

In 1007/8, the Bishop of Hildesheim (in present-day northern Germany) commissioned perhaps the most magnificent bronze doors from the early Medieval period for the church of St. Michael's. Completed in 1015 and later moved to Hildesheim Cathedral, these doors incorporated eight pairs of relief panels with Old and New Testament scenes. They exemplified the type of arrangement and iconography established for church doors in wood and set a widely followed precedent for future, more ambitious ecclesiastical projects in bronze. The exterior surface was organized as a series of panels framed by borders of floral or abstract patterns. The panels provided space for relief scenes illustrating a narrative sequence, such as the Life of Christ, or portraying a series of symbolic figures, such as the Evangelists or the Church Fathers. The format of paired doors allowed the narrative to unfold horizontally across both doors or vertically within each door so that strategic juxtapositions could occur, as at Hildesheim, where mankind's Fall and Expulsion from Paradise on one door culminates in Christ's sacrifice (page 57) and divine Redemption on the other. The transition from sin to blessedness inherent in such iconography could provide an exemplar for the worshipper who crossed the threshold of the church portal and was led away from the material world and toward the spiritual, supplanting transgression with salvation.

Despite the early Medieval tradition of covering church doors with bronze reliefs, the great era of soaring Gothic cathedrals emphasized carving over casting, and a building's monumental, complex, three-dimensional figurative decoration was often rendered in stone around the doors, becoming part of the cathedral's architectural

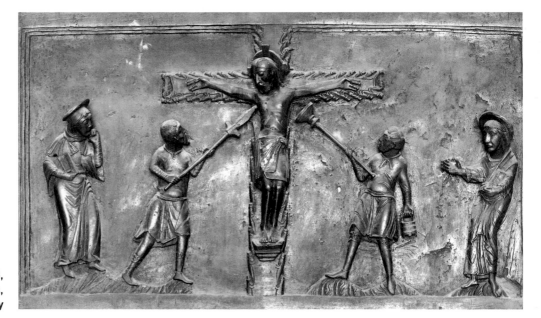

fabric. The casting of sculptural bronze doors continued only in Italy. The Gothic tradition was well represented by Andrea Pisano's bronze doors for the Baptistery in Florence (see page 58), begun in 1330 and completed seven years later.

But perhaps the most famous bronze doors in Europe were those commissioned for the same Baptistery one hundred years later. In the winter of 1400–01 the Guild of Cloth-dealers and Refiners announced a competition for a set of bronze doors to be placed on the east side of the Baptistery, facing the great Florentine cathedral. The doors were to mediate the spatial and symbolic relationship between the two religious monuments, as well as the transition between public square and devotional interior. Seven artists competed for the opportunity to execute the doors by submitting a relief panel depicting the Sacrifice of Isaac. The winning sculptor, Lorenzo Ghiberti (1378–1455), was a highly esteemed Florentine goldsmith and bronze caster, and his victory over the other sculptors was due as much to his technical expertise and innovation as to his artistic talent: he cast his competition relief in one piece, which required less material and so would presumably make the final work less expensive to produce. The resulting doors, consisting of twenty-eight relief panels of figurative and narrative scenes depicting the Life of Christ, the Evangelists, and the Fathers of the Church took more than twenty years to complete. A comparison of Ghiberti's *Baptism of Christ* panel and the same subject from Pisano's doors (see page 59) demonstrates how far art had advanced in the intervening century. In contrast to Pisano's linear arrangement of figures and schematic depiction of water, Ghiberti's concern with illusionistic effects in the overlapping of figures, his careful attention to naturalistic landscape details in the delicate foliage and undulating waves, and the classical pose of his nude Christ, all

Andrea Pisano (circa 1290–after 1348), South Doors, bronze, 1330–36, Baptistery, Florence

attest to his development toward a full-blown Renaissance aesthetic.

Ghiberti then won a second commission for another set of Baptistery doors, which he worked on for the next twenty years. This latter set, depicting scenes from the Old Testament, was completely gilded and given pride of place on the Baptistery's east side, with the earlier pair being moved to the north side. The sophisticated relief style that Ghiberti had by then developed, no doubt coupled with the dazzling effects of the gilding, earned these doors the title *Gates of Paradise* (see page 60).

The production of monumental bronze doors languished during the eighteenth and nineteenth centuries, a victim, in part, of changing tastes. In the Neoclassical period, white statuary marble was the material most closely associated with the classical past in the minds of antiquarians, theorists, patrons, and artists, and as they re-examined antiquity through eighteenth-century eyes, marble became the dominant sculptural medium throughout Europe. Toward the end of the nineteenth century, bronze cathedral doors became popular again partly because of a general revival of historical styles. Perhaps more important, however, nineteenth-century Romanticism also produced a much greater interest in the use of bronze as a material, which derived from that era's fascination with artistic temperament and the process of creative generation. Today's archetypal notion of the struggling artist, whose inner torment results in acts of visual genius, stems from the cult of personality prevalent in that period. Sculptural materials that retained evidence of the artist's touch and the marks of his tools—considered visible manifestations of the inner workings of his creative soul—became more popular. Even the greatest Neoclassical theorists, such as Johann Joachim Winckelmann, had understood that, just "as juice from the first pressing of grapes makes the best wine, so the genius of an artist is displayed in all its naturalness and truth in works in soft material." By the mid-nineteenth century that natural revelation of genius was

Andrea Pisano, *The Baptism of Christ,* bronze, 1330–36, detail from the South Doors, Baptistery, Florence

Lorenzo Ghiberti (1378–1455), *The Baptism of Christ,* bronze, 1403–24 detail from the North Doors, Baptistery, Florence

valued not only in the preparatory model, but also in the final work of art. One of the advantages of bronze casting is its ability to record and preserve in permanent, enduring form the tool and finger marks that the artist used to create his original conception in a soft material like clay or wax. Like the Impressionist painters who used loosely applied and clearly discernible brushstrokes on their two-dimensional canvases, nineteenth-century sculptors elevated the aesthetic of the model or sketch in three dimensions using tool and finger marks.

Auguste Rodin (1840–1917) was the great proponent of an aesthetic for sculpture that evoked the process of creation. In his final works, whether terra-cotta, plaster, or bronze, one can distinguish the vigorous gouging of his fingers to establish forms and facial features, the marks of his tools as he shaped and detailed the composition, the texture of cloth used to strengthen seams or drape the wet clay model, and raised lines remaining from the use of molds—all of which the artist chose to retain rather than remove (see detail page 61). Even his marble sculptures reveal the energetic marks made by his chisel, and he often left a mass of rough-hewn stone as a reminder of the original block from which the figure or composition seems miraculously to emerge.

Rodin himself undertook the production of a great set of bronze doors for a Paris Museum, and it is perhaps evidence of an increasingly secular society that they were commissioned as a threshold of culture rather than religion, with art, rather than ritual, providing the vehicle for spirituality and salvation. Commissioned in 1880 by the French Minister of Arts as the entrance for a planned new museum of decorative arts, the project occupied Rodin for the remainder of his career. Rodin consciously emulated Ghiberti's *Gates of Paradise* in conceiving this gateway, choosing for his theme a

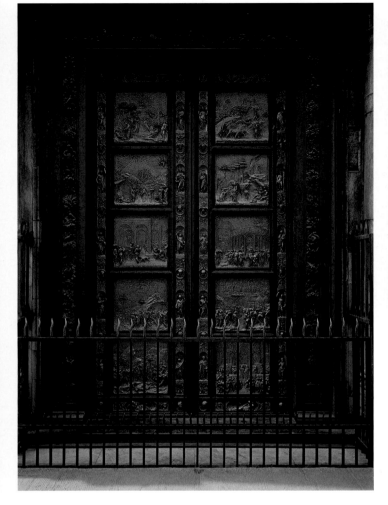

Lorenzo Ghiberti, **The Gates of Paradise** (East Doors), bronze, 1425–52, Baptistery, Florence

Lorenzo Ghiberti, **The Story of Joseph,** bronze, 1425–52, detail from The Gates of Paradise, Baptistery, Florence

celebrated masterpiece of literature from the Florentine Renaissance, Dante's *Divine Comedy,* and adopting a title for his doors—the *Gates of Hell*—that directly responded to that of Ghiberti's portal. Rodin's initial composition for the doors also echoed the traditional organization of compartmentalized relief scenes exhibited by Ghiberti's narrative panels. Rodin, however, soon abandoned this arrangement in favor of a chaotic mass of human figures writhing and spilling out of the relief surface, tormented by love, pain, and the irrevocability of their sins. Unfortunately, the museum for which the doors were commissioned was never built, and the French government ended its official interest in the project by the late 1880s. Rodin continued to work on the doors, however, and the figural groups he invented for that context became independent compositions that he could vary endlessly in different materials and sizes. Although he repeatedly made plans to assemble and cast the doors, the *Gates of Hell* were only realized in bronze in 1925, eight years after the sculptor's death. That version is now in the Rodin Museum in Philadelphia; the version of the *Gates of Hell* shown here (page 61), cast in 1981, is in the Iris & B. Gerald Cantor Center for Visual Arts, Stanford University.

These were just some of the precedents that confronted Robert Graham when he received the commission to produce bronze doors for the Cathedral of Our Lady of the Angels. This project marks the third time in his career that he has undertaken the sculpting of a gateway in bronze. The first project, *Dance Door* (see page 62), was made in 1978 for the collectors Marcia and Frederick Weisman, who donated it to the Los

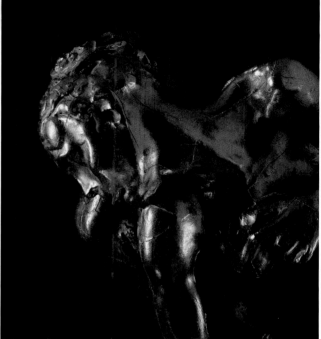

Auguste Rodin (1840–1917),
The Gates of Hell, bronze, 1880–
circa 1900 (this version cast
1981), Iris & B. Gerald Cantor
Center for Visual Arts, Stanford
University

Auguste Rodin,
The Crouching Woman (detail),
painted plaster, circa 1880–82,
Los Angeles County Museum of Art

Angeles Music Center, where it can be seen today. This freestanding bronze doorframe, with its door in a permanently open and inviting position, celebrates the human body and its infinite potential for variation in gesture, pose, and movement. The scale of the door is also human and familiar rather than monumental and compels the viewer to come closer and walk through it to enter the plaza of the Music Center. The reliefs in *Dance Door* retain evidence of the rectilinear borders defining the clay slabs from which they were modeled, suggesting a series of panels like traditional church doors and like the entryway for the Cathedral of Our Lady of the Angels. Here, however, the edges defining the panels are subtle and soft, as they would have been in clay. Low-relief female nudes in elegant and active movement, seen frontally and from behind, cover the surface of the lower panels. In the upper register larger, more fragmentary female nudes in relief stand in relaxed poses. Seam lines and areas where the clay of the original model has been peeled away or added on—passages that could easily have been repaired or smoothed over before or after casting—are left in the bronze as visible reminders of the artist's working process and the soft material in which he first developed his sculptural conception.

Graham's next project for an entryway was much grander in scale and ambition. The *Olympic Gateway* (see page 63), was commissioned by the Los Angeles Olympic Organizing Committee for the 1984 games and permanently installed in front of the Los Angeles Memorial Coliseum. This portal consists of two round columns decorated with figures, set on square bases with nude torsos emerging from the flat background

Robert Graham, *Dance Door*, bronze, 1978, Los Angeles Music Center Plaza

of bronze. A rectangular bronze lintel, bearing four more relief panels with torsos seen from the front and behind, surmounts the columns. On top of the lintel, a pair of heroic nudes, one male and one female, both cropped at the neck and below the knees, stand on inverted cones of gilded bronze that suggest the fire of the Olympic torch. Although not literally a door, the *Olympic Gateway* serves as a portal to a world of physical perfection, soaring ambition, and human achievement on a monumental scale. In its size and its use of gold to suggest fire or light, this project, like *Dance Door* with its evocation of panels and reminders of artistic process, helped established a direction for Graham's work on the Los Angeles cathedral doors.

Graham's increasing involvement with monumental public commissions inspired him to explore new methods to overcome the challenges of enlarging small-scale models while maintaining the desired level of detail and surface variation. By the 1980s Graham began using laser technology to scan his models, recording a nearly infinite number of points in three dimensions. In this process, computer software enlarges the image proportionally and achieves a remarkable degree of accuracy due to the sheer number of reference points defining the surface contour (see page 79). Computer-generated images allow the sculptor to rotate his creation, virtually, in any direction and view it from every angle. The computer files are transmitted to a robotic milling tool that carves through multiple layers of clay to execute a full-scale model. The mill can be fitted with different sizes and types of rotating heads that produce any combination of directional lines as they cut into the soft material.

These milled clay forms serve as the final, full-scale models from which molds are taken to make waxes for casting the bronze. Their surface bears the imprint of the marks left by the mill head, whose form, pattern, and direction were determined by the artist. Graham could, if he wished, smooth over these lines to achieve a pristine surface and to erase all evidence of the machine. He could also cover the smoothed surface with his own, more traditional marks made with fingers and simple handheld

Robert Graham, *Olympic Gateway*, bronze, 1984, Los Angeles Memorial Coliseum

tools. This latter approach, however, would reveal not the actual technique of executing the model, but a staged, romanticized process catering to conventional notions of artistic production. Instead, he chooses to consider the milled surface his own. In other words, Graham conceives these patterns as equivalents for the artist's touch, and treats the milling arm as an extension of the artist's own hand (see page 64). The machine-made grooves and surface patterns, in Graham's view, embody evidence of the artist's working process in the same way that, traditionally, fingerprints and tool marks were considered testaments to artistic creativity. In this stunning inversion of conventional expectations, man and machine have become one, and truth to the artistic process dictates that the milling arm—like the artist's hand—has a role to play in the creative endeavor that is essential to the aesthetic outcome and therefore cannot be erased without sacrificing the integrity of the work of art.

This innovative use of modern technology poses almost as many problems as it solves. Adjusting details in the clay model means disturbing, or even destroying, the marks of the mill and thus sacrificing the evidence of artistic process. Once the clay models are complete, Graham follows traditional bronze-making techniques, taking molds to produce wax replicas, which are then cast in metal. Because clay models are damaged when molds are taken, they cannot be re-used if the molds are unsuccessful, and the pattern of the mill head can never be replicated exactly as it is highly sensitive to temperature and other environmental conditions. Once the models have been milled, the stringencies of Graham's approach permit fewer possibilities for change and experimentation than traditional techniques (see page 65). The benefits, however, are enormous. They allow Graham both to retain the subtle nuances of his original conception during the transfer to a large scale and to cover a large bronze surface with animated, energetic textures and marks that activate his forms and require little polishing in the cast metal. Like other monumental bronze portals created for churches and religious buildings throughout the history of Western art, Graham's doors for the Los Angeles cathedral stand at the forefront of technical innovation.

Robert Graham, with the milling machine, at work on the clay models for the relief panels.

As Graham suggests, his method of incorporating new technologies into traditional bronze-making creates greater opportunities for architectural sculpture. The technique allows intricate, as opposed to generalized, works to be incorporated into the fabric of a building and still meet the deadlines and budget limitations imposed by major construction projects. Graham unites both traditions of church portal decoration: the bronze entryway with its complex iconography of symbolic panels in relief, adopted in Graham's scheme for the inner doors, and that of the Gothic door surround with its three-dimensional architectural figures, manifested in Graham's crowning figure of the Virgin. Graham's project reflects the greatest achievement of the bronze relief tradition while also embracing the most significant feature of Gothic church sculpture in stone by using the three-dimensional Virgin as an architectural element. His choice of technique enables the portal to develop as part of a twenty-first century construction timeline and therefore as part of the architecture itself.

Unlike Graham, whose doors were in place when the first Mass was said at the new cathedral in the autumn of 2002, Ghiberti was not able to install his *Gates of Paradise* until fifteen years after completing the rough casting of the ten relief scenes in 1436–37. The intervening years were spent finishing and polishing the details of the panels, gilding them, constructing the doors' framework, and assembling the whole. Due to the state of technology at that time, Ghiberti's bronze relief panels were variations rather than translations of his original models and required extensive and time-consuming reworking and refining in the cold metal after casting. It is unlikely that a comparable timeframe would be acceptable within a twenty-first century architectural commission. But Graham has developed a method to translate, more or less exactly,

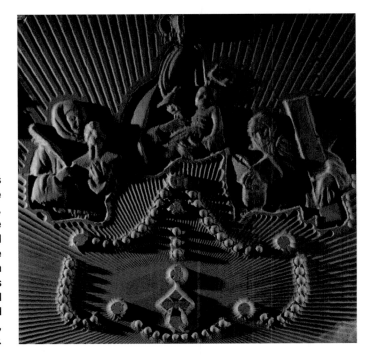

Clay model showing the tool marks left by the milling machine. The machine carves the clay in layers, as seen here. The outer layers are carved using a larger mill head that leaves wider grooves. Once the outer layers have been removed, a smaller mill head is used for finer, more detailed carving of the forms. This mill head leaves more delicate, narrow grooves in the surface.

the soft model into cast metal without the need for further refinement. In this sense, he captures the promise of Rodin's modern sensibility and its celebration of artistic process. He also enables his sculpture to become an integral element of the cathedral, a part of both its architecture and meaning.

Graham's bronze doors for the Cathedral of Our Lady of the Angels represent the mundane and spiritual thresholds embodied in any church portal. They mark the transforming passageway through which the worshipper enters the ambulatory and proceeds to the body of the church with its promise of comfort and salvation. The doors establish the transition point, the crucial first steps in that physical and emotional journey. Their iconography embraces and embodies the memory of past worship. Their medium of bronze commemorates and honors history—paying homage to artistic tradition, identifying the building as a cathedral, and giving substance to Los Angeles' civic and religious pride by incorporating the persona for whom the church and the city were named—Our Lady of the Angels. Graham's project belongs to a long tradition in which ecclesiastical bronze doors extend the limits of a society's technological ambition because of their difficulty and expense. In that sense, they represent yet another kind of threshold—that of industrial achievement. Robert Graham's great bronze doors, with their lustrous surface punctuated by the grooves of a computerized milling tool, signal future possibilities for innovation and discovery.

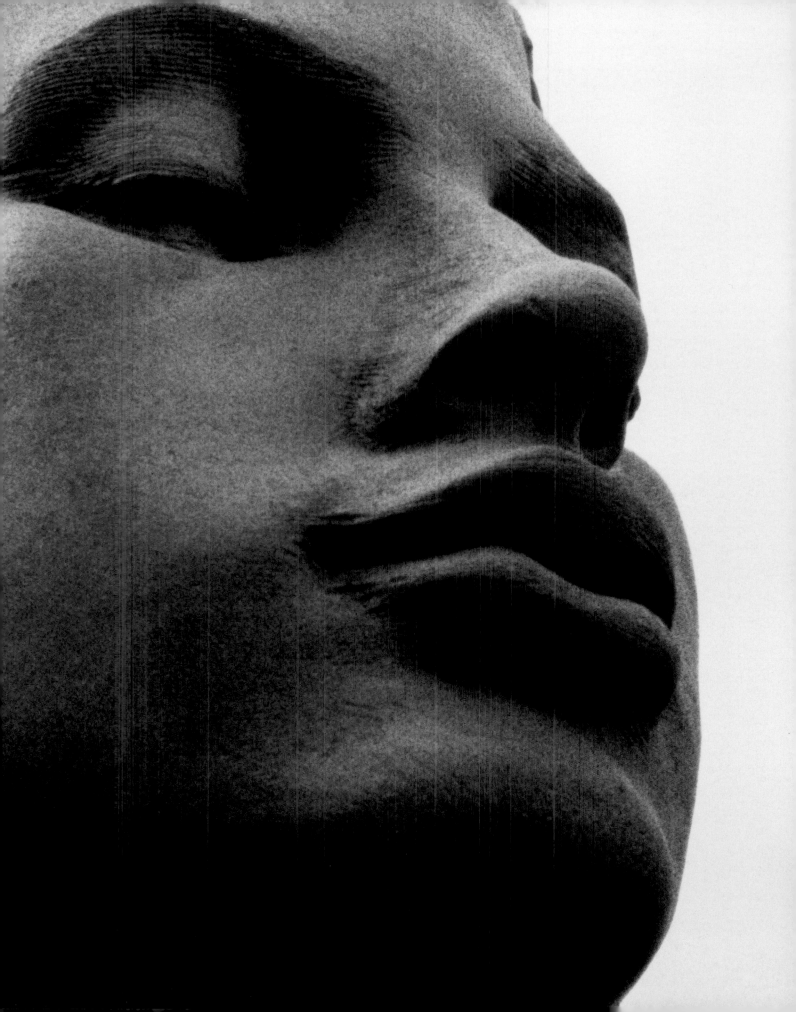

TECHNICAL
PROCESS
AND
REALIZATION

by Noriko Fujinami

< **Work in progress at the artist's studio in Venice, California, December 2001**

IN JANUARY 1995, Cardinal Roger Mahony, Archbishop of Los Angeles, announced plans for a new cathedral. A site at Temple Street, between Grand Avenue and Hill Street, two blocks from the City Hall, was selected, and José Rafael Moneo of Spain was chosen to design the new cathedral. The ground-blessing ceremony took place on September 21, 1997, and the preliminary design of the cathedral was announced. This included two large openings for bronze doors, and when Cardinal Mahony contacted Robert Graham and inquired about his work, he responded with great interest. The selection process included the appointment of Father Richard S. Vosko to serve as liturgical art consultant and the formation of Art and Furnishings Committee to review a list of artists for the commission. In June 1998 Robert Graham was invited by Father Vosko to present a formal proposal for the doors to the Art and Furnishings Committee on July 1.

As part of his presentation to the committee, Graham made small bronze models showing his concept for the doors. In the model he divided the thirty-by-thirty foot opening into thirds. He proposed that the top third be a tympanum; the remaining two-thirds were divided again into thirds, forming the two large inverted L-shaped doors surrounding the two inner doors, creating a door within a door. The four separate doors could open and close in varying configurations. This concept did not change during the five years Graham worked on the Great Bronze Doors for the cathedral.

Schematic drawings for the south doors, August 1998.

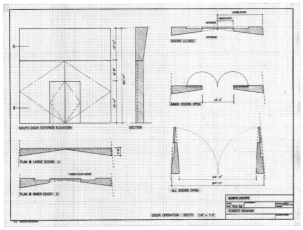

The artist was given thirty days to prepare and present his ideas before the Arts and Furnishings Committee, and Graham, with his studio assistants, devoted the entire month of June to creating models and presentation materials for the meeting. The seven-and-a-half-inch-square model for the south doors was fabricated in bronze.

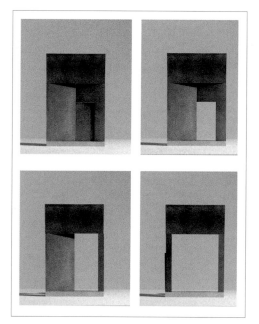

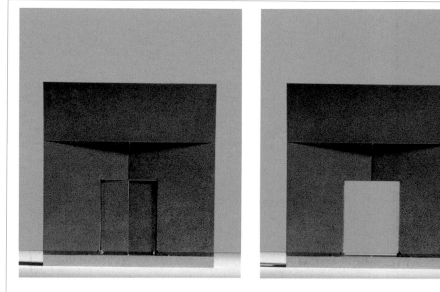

Although the model for the north doors was developed, plans for this entrance were put on hold in February 2000 until funding could be found. The artist intended to divide these smaller Thirty-by-twenty-foot doors into four sections, with the smaller doors opening as a unit. This model was also fabricated in bronze, and measured seven-and-a-half by five-and-a-half inches.

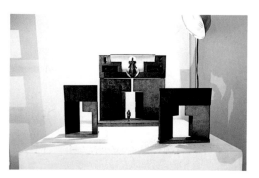

Models of doors at the artist's studio.

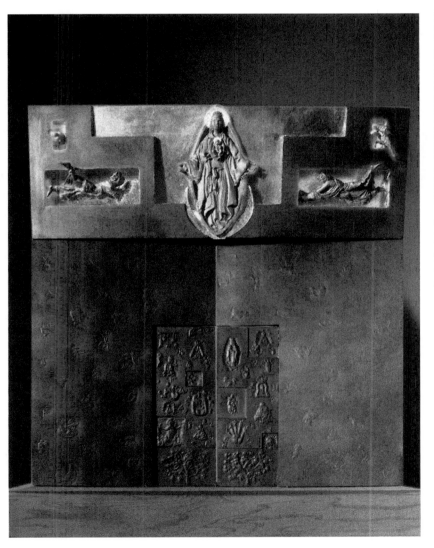

On December 21, 1998, Cardinal Roger Mahony held a press conference at the office of the Archdiocese of Los Angeles announcing that Robert Graham had been commissioned to design and create the cathedral's doors.

A model of the doors was presented at the press conference. It shows Graham's first sketch of Our Lady of the Angels in the center of the tympanum with two attendant angels, one on either side. Above the angel on the right is a lily, a symbol of Mary's birth without original sin and her virginity. In the matching position on the left is an apple, symbol of her role as Second Eve. Various manifestations of the Virgin are shown on the inner doors and reliefs of religious and cultural symbols adorn the outer doors.

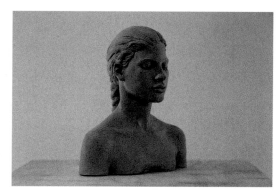

Study for the Virgin, seven inches in height, polyurethane cast made in December 1998.

By December, Graham created a small study bust of the proposed figure of the Virgin in plastilene, an oil- and wax-based clay that holds fine detail and does not permanently harden. To obtain a durable replica, a flexible mold in silicone rubber was made from the original clay master, a process that destroys the original. Polyurethane, which quickly hardens, was poured into the mold, and a durable replica of the original clay master was produced, a model that could then be handled and studied.

At the press conference Graham described his concept for the doors: "The iconographic program for the South Great doors will include a central image of Our Lady of the Angels on the tympanum above the pair of large doors depicting ancient iconic imagery in low relief. A pair of smaller doors in high relief will have images of various manifestations of the Virgin in the New World, as well as a depiction of the grapevine (symbolic of the Church), with images and symbols of the ethnic and cultural diversity of the Los Angeles Archdiocese."

To create a full-length figure of the Virgin, Graham created a standing figure, approximately thirty inches tall, in plastilene. A silicone rubber mold was taken of this figure, and polyurethane casts were made so the artist could design the outer garment. Several studies were completed, and after designing the final garment for the figure, patterns were made for the bodice, sleeves, and skirt. Using soft cotton cloth dipped in starch and fabric glue, he formed the garment directly onto the polyurethane figure. Because the glue dries and stiffens rapidly, the wet cloth had to be worked very quickly to secure the exact folds and creases he desired.

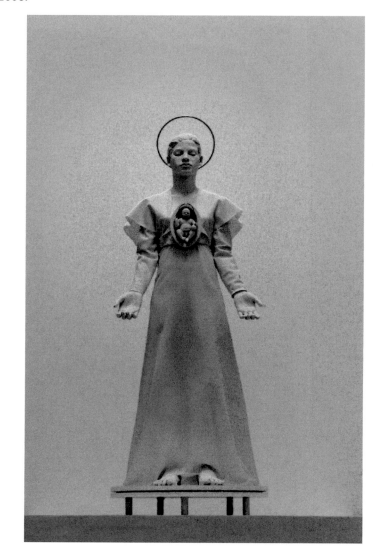

Study for the Virgin figure, thirty inches in height, cast in polyurethane and covered in painted cloth. It includes the figure of the baby Jesus over her heart. This version was revised.

The Church Doors symbolize a bridge over which we may travel back and forth across ages and systems of belief.
—Robert Graham

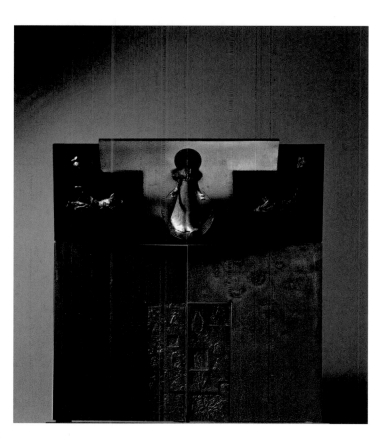

Third model of the doors, made in spring 1999, showing the extension of the tympanum, and the addition of the oculus above the Virgin. South doors closed, in morning light.

This shows the south doors open, in afternoon light.

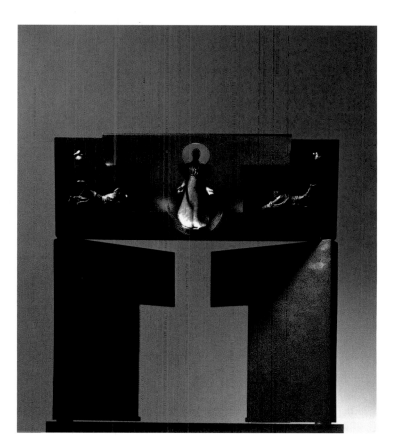

A number of attempts were required to achieve the finished study of the Virgin figure. The initial design, which included a small model of the infant Jesus over the Virgin's heart, was at once rejected, as it did not properly portray Our Lady of the Angels. The Cardinal explained "the mystery of Our Lady of the Angels is really a post-Resurrection mystery, and Mary gained that title once she was assumed into Heaven. This follows the Resurrection of the Lord, the Ascension of the Lord, and the coming of the Holy Spirit upon the apostles and the Church. Consequently, the statue of Our Lady of the Angels is best rendered without the presence in any form of the infant or child Jesus" (see "Our Lady of *Los Angeles*," page 42, note 4).

The removal of the infant Jesus redefined the Virgin figure. It was at this time Graham added an oculus (a circular opening) to the tympanum, allowing light to form a natural halo around the Virgin figure (see discussion about the light in "Our Lady of *Los Angeles*," page 41, note 3). The placement of the Virgin on the tympanum was adjusted so that she leaned slightly forward. Her garment was simplified. In April, a second thirty-inch study was presented to the archdiocese and was accepted without further changes. This figure of the Virgin became the center of what shaped and defined the program that followed for the Great Bronze Doors.

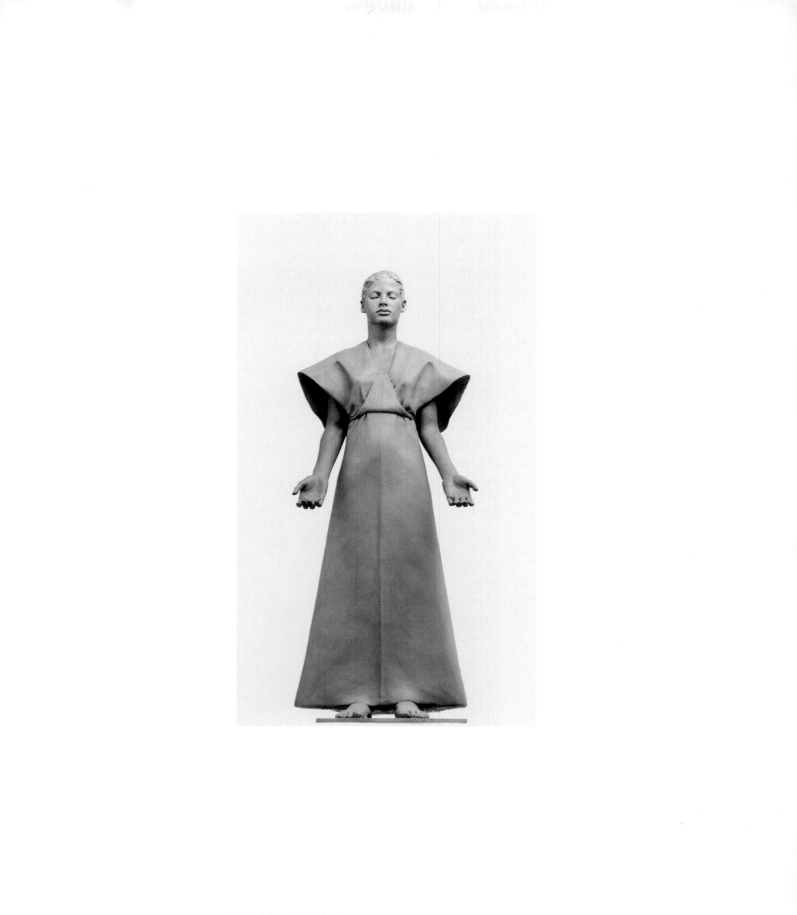

Model for the Virgin figure.

THE LARGE MODEL

In the spring of 1999, in proportion to the thirty-inch figure of the Virgin, a large model of the doors was built in plywood at Graham's studio in Venice, California. At approximately one-third scale, the plywood model measured ninety-nine inches in height and width. For the next three years, Graham used the large plywood model of the doors as a kind of three-dimensional working drawing on which he tested new ideas.

In July, with the polyurethane cast of the Virgin installed on the tympanum, a three-dimensional laser scan was made at the studio. Scanning or "digitizing" is the computer process of recording the surface of an object.

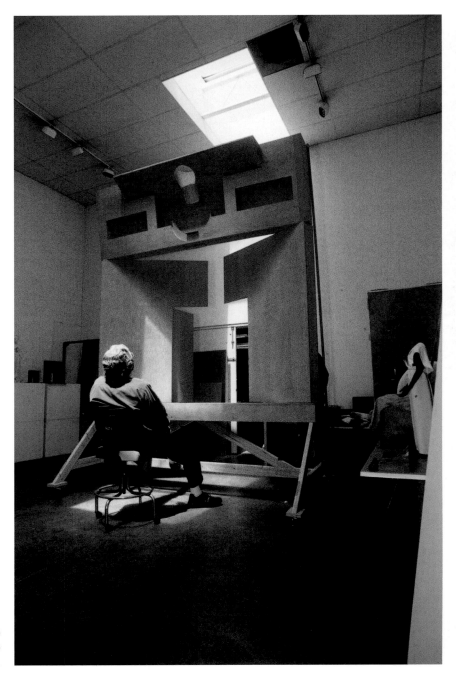

The large plywood model of the doors was made in proportion to the thirty-inch figure.

Metal points have been placed on the tympanum, preparing it for a laser scan. The surface of the doors was scanned and the information digitized so that measurements in the preliminary drawings could be corrected. The data collected by the scanner are called "point clouds," a collection of points each with an x, y, and z coordinate.

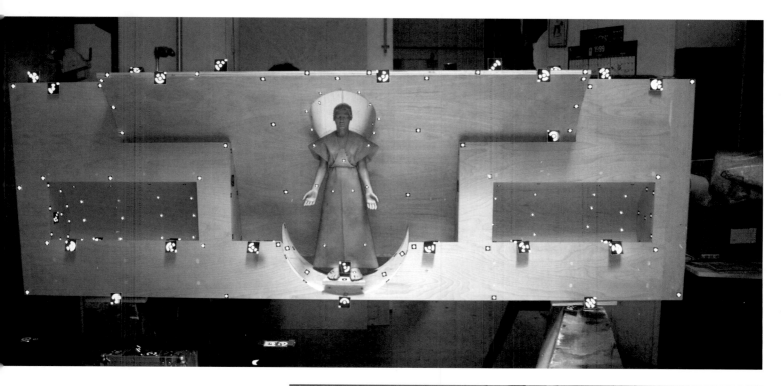

Scanning the door model in the studio. Graham studio assistants watch as Rick White of Capture 3-D operates the scanner. Johan Gout is at the computer, which records and translates the data.

To scan the model, a portable scanner was brought to the studio. Metal points were placed as references on the plywood and, as the laser swept over the surface, the range of distances and curves between each point was collected and transferred into high-resolution data. Because the sensor sweeps linearly across an object or circularly around it, multiple passes must be made from different angles to reconstruct the object. Information gathered by scanning is transferred in the computer, and software written specifically to read scanned data merges the information collected from the different passes. The information gathered by the laser scan was used to correct the measurements in the preliminary drawings for the design and fabrication of the doors.

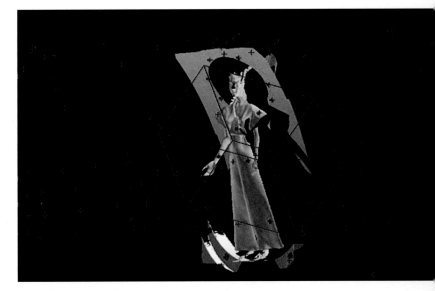

Laser light from the scanner forms a pattern on the Virgin figure. Rick White of Capture 3-D checks the scans in the computer while Johan Gout operates the scanner.

Computer-generated images of the laser scans of the Virgin figure inside the tympanum. The scanned image can be rotated in the computer and viewed at any angle for a full 360 degrees.

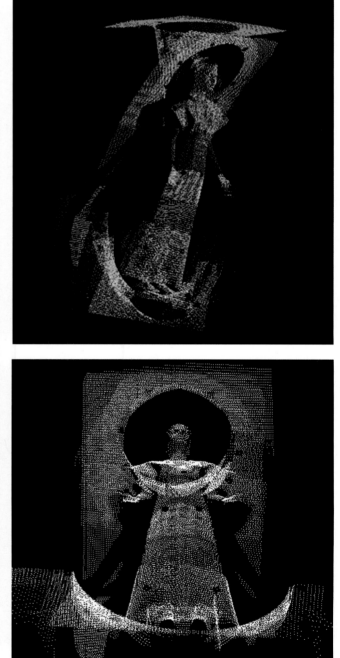

THE INNER DOORS

In the summer of 1999, after extensive research and study of hundreds of images of the manifestations of the Virgin Mary from different parts of the Americas and the Western Hemisphere, Graham made fifteen studies in plastilene.

Nine images were depicted in eight-by-eight-inch squares: the Virgin of Pomata, an ex voto to the Virgin of Guadalupe, the Virgin of the Candlestick with the Virgins of Belén, the Virgin of Mercy, the Virgin of the Rosary of Chichinquira, the Virgin of the Cave, the Virgin of Montserrat, the All-Powerful Hand with the Holy Family, and the Virgin of Loreto. A double panel of the Virgin of Guadalupe was made sixteen-by-eight inches and beside it another double panel of Apocalyptic Virgin/Immaculate Conception above the Virgin as Divine Shepherdess. Last panel was divided into three and depicted images of the *Mater Dolorosa*, the Virgin as Sorrowful Mother, the Chalice with Sheep, and the *Pietá*. (see "Our Lady of *Los Angeles*" for more information about the manifestations of the Virgin.)

The remaining six squares were used to depict two panels of the grapevine, a symbol of the Catholic church, with forty ancient and ethnic symbols (see complete list on pages 48–49) representing the cultural diversity of Los Angeles, in which Mass is said daily in more than forty languages.

Silicone rubber molds were taken of each panel, and polyurethane casts were made and glued onto the plywood door model.

The plastilene clay panels of the manifestations of the Virgin (above) and the entire door model (right).

80

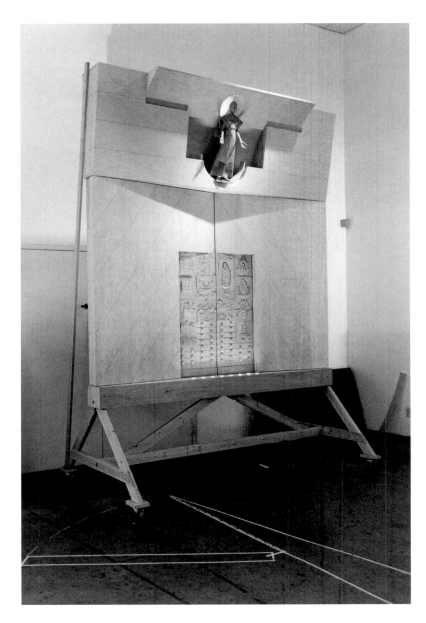

SCANNING

A set of polyurethane casts of the inner door panels was sent to Scansite, a digital scanning facility in Marin County, California, which would prepare the highest resolution laser scans possible. These scans would be used to enlarge and mill the small doors at their final size.

Several different types of scanner were used for scanning the panels. A low-resolution laser scanner was used to make the initial "template" scan. Sections of the panel were cut into pieces and scanned using high-resolution laser light as well as sound-waves. The laser scans by projecting light onto the surface of an object, while the sound-wave scanner measures sound-waves emitted from a probe lowered to one-half micron above the surface of the object.

The range of data is collected in triangular coordinates that form "point clouds." Individual scans are viewed for accuracy and unacceptable data deleted; information from the scans is then merged. A CAD (computer-aided design) program takes the data to create a surface over the point clouds called "Nurbs" (Non-Uniform Rational B-Spline), which is a way of describing a three-dimensional

object with a series of mathematical or "parametric" equations, instead of individually listing each one of the millions of points. A Nurbs surface is necessary for the CNC (computer numerically controlled) milling machine to reproduce an object. The file containing the information is sent to a milling facility via an FTP site (File Transfer Protocol is the method by which large files are uploaded and downloaded on the Internet).

Computer-generated image of the scanned data showing the same panel, with the All-Powerful Hand to the right.

Plastilene clay panels of the All-Powerful Hand (center), with the *Pietá* and Chalice with sheep (left), and *Mater Dolorosa* (right).

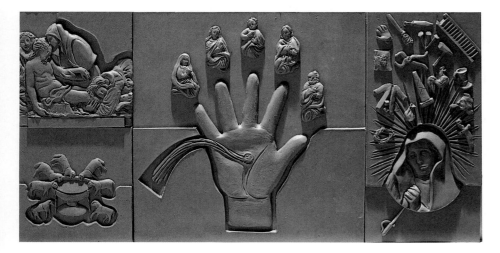

This screen shot shows the detail of the point cloud data, and illustrates the depth of *x*, *y*, and *z* coordinates of the All-Powerful Hand image.

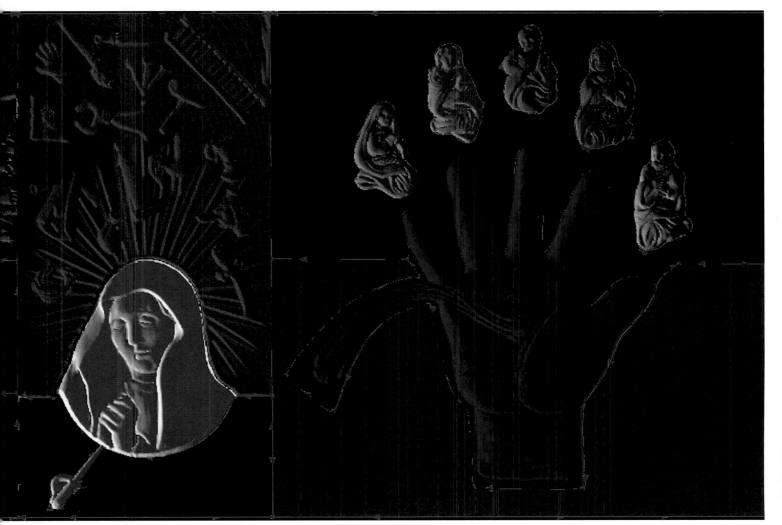

MILLING

Milling the panels was a two-step process. The first step was "toolpathing," a process of translating the digital file into a series of paths for the milling tool to follow as it carves the object from a block of raw material. Four different software packages —Surfcam, Imageware, Maquette, and Geomagic— were used by the artist to transfer the digital data. All the milling for this project was done at CTEK in Tustin, California, using a five-axis Gantry milling machine with ten-by-ten-by-seven-foot capacity. The milling machine can cut from a variety of materials, most commonly foam, wood, aluminum, wax, and clay. For this project, Graham selected plastilene clay, which was formed on top of rigid foam glued to aluminum honeycomb board.

The second step is the actual machining, which involves translating the toolpaths into smaller steps that move the head of the milling tool. The five-axis machine is capable of moving in five different directions. The object can be enlarged or reduced as desired; the only limitation is the size of the milling machine. Each eight-inch-square panel was enlarged to a thirty-inch-square format to allow for the two percent shrinkage that customarily occurs in bronze casting. The shrinkage allowances are best-guess estimates because there are a number of variables that are difficult to control: the size and thickness of the wax cast and the temperature of the molten metal and its rate of cooling. In most casting, a difference of two percent is not significant, but for this project an exact size was essential for assembling the panels to fit a precise area.

Toolpaths on the milling machine operates as vectors, and they position the milling bit in space. A starting point is determined and the milling begins with large, rough cuts. The ball end of the mill bit excavates the object by slowly removing layer after layer of material in a stepped-down process called "depth cuts," in which the diameter of the bit is changed as it steps down to achieve a detailed surface. The machine can be set to cut at 5/1000 inch. The artist used the milling machine like a sculpting tool, making spontaneous decisions on depth of cuts, toolpaths and mill bits, to achieve a surface that shows a distinctive series of lines, spirals, and layers left by the milling tool.

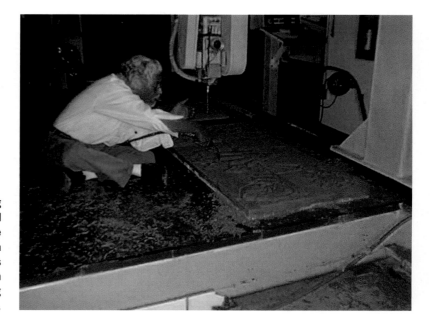

Graham sitting on the milling machine at CTEK, watching the mill bit cut the plastilene clay panel. He used the milling machine like a sculpting tool, making spontaneous changes in the toolpaths and depth of cuts. Marks left by the milling tool were carefully preserved.

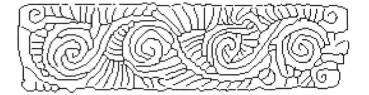

Original design pattern; digitally translated design pattern.

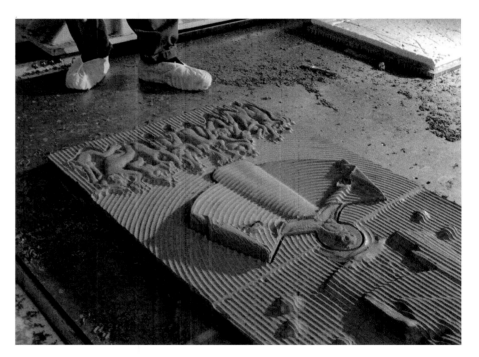

Detail of the Virgin of the Candlestick panel being milled.

The design pattern was added as a detail to the next depth cut.

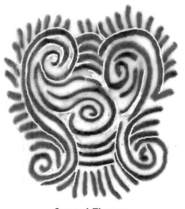

Sacred Flower

Scans of all forty symbols. Each symbol was originally
made in one-inch plastilene clay. Polyurethane casts
were made and scanned using laser and sound-wave
scanning. (Symbols are listed on pages 48–49.)

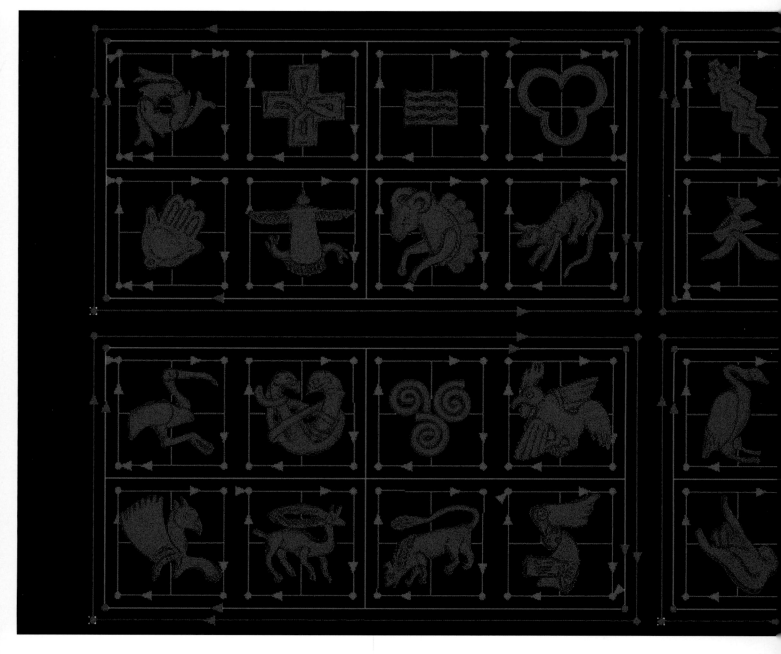

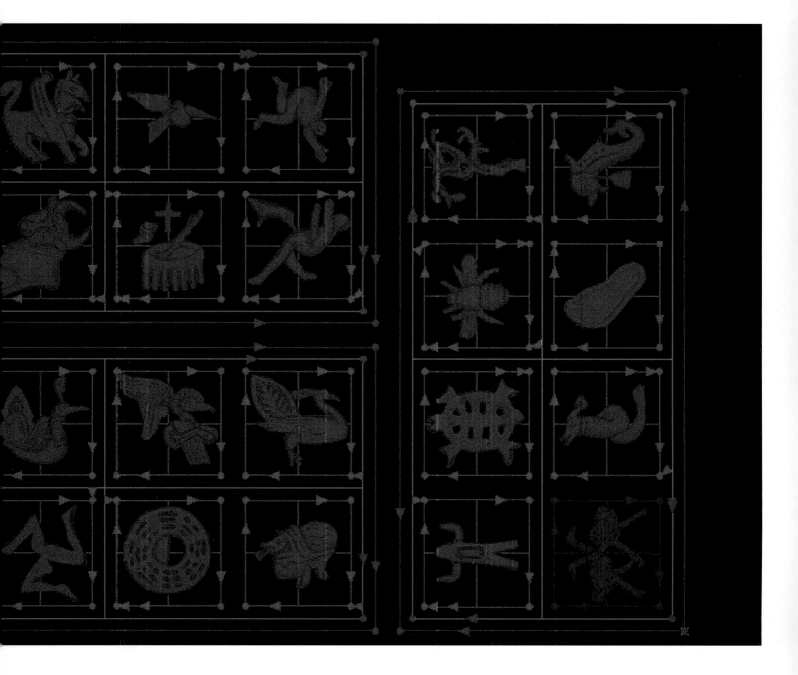

Right: Symbols were enlarged to four-inch squares and milled in plastilene clay.

Lower left: The grapevine panels.

Lower right: Detail of the grapevine panel with its flat square area for the symbols.

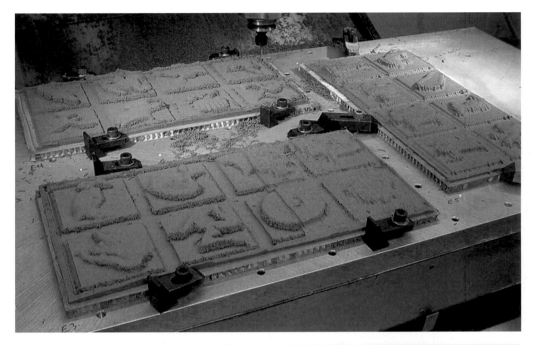

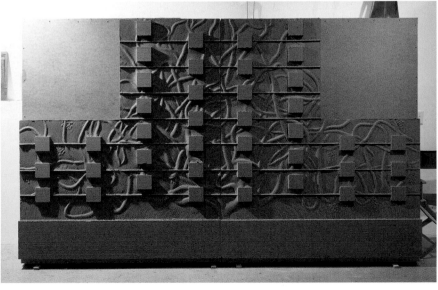

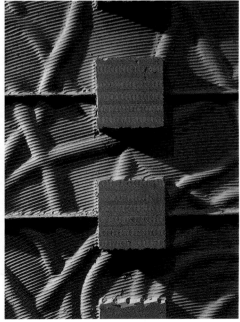

Plastilene clay panels of the manifestations of the Virgin. This photograph was digitally created from several photographs to illustrate how the full-scale inner doors would look before the moldmaking process destroyed the milled clay panels.

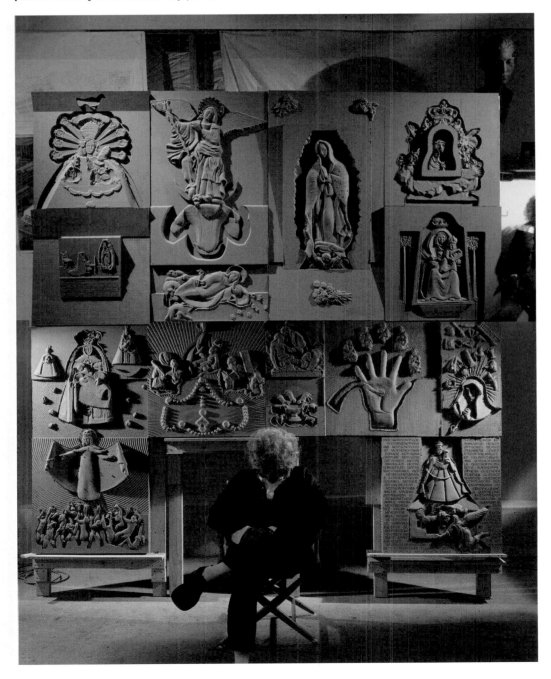

MOLDMAKING

The milling of the panels was completed in February 2000, and molds were made for each panel at the artist's studio. There are a variety of moldmaking methods, and individual formulas and techniques are adapted for the best results. To cast the door panels, molds were made using polyurethane rubber mixed with fumed silica for a stronger bond. The molds were further strengthened withs layers of fiberglass and formed in plaster. From the mold, a master cast was made in aqua-resin, a lightweight and sturdy plaster-like material. These panels were hung on a studio wall for study (see photograph on page 6).

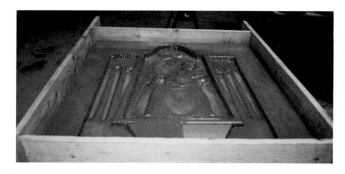

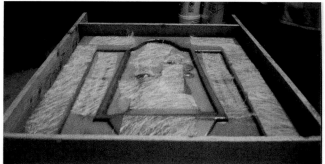

Moldmaking in process. Each milled plastilene panel was framed and molds created from polyurethane rubber strengthened with fiberglass.

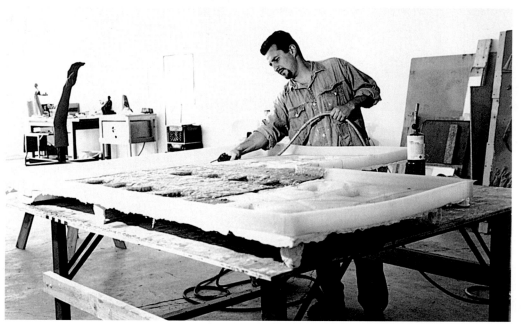

The mold for the large grapevine panel being prepared for casting by Juan Carlos Muñoz Hernandez.

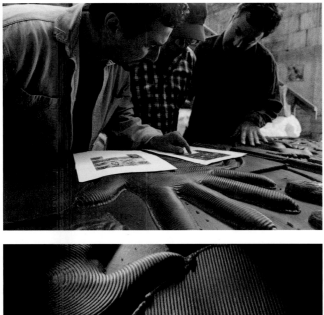

Discussing the casting of the panels at
Artworks Foundry in Oakland, above

Detail of the wax square of the All-Powerful Hand

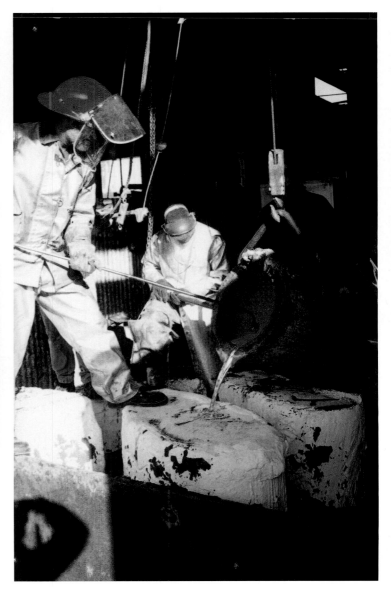

Lost-wax process. Bronze is heated to a
temperature of more than two-thousand degrees
and poured inside the heated ceramic shell.

CASTING

Three separate foundries were used for casting in bronze. The molds of the large Virgin panels were sent to Artworks Foundry in Oakland, California. First, a layer of melted wax was poured into each mold. The hardened wax was removed from the mold, and vents and pouring cups were added to the wax. The wax was coated with layers of ceramic material and sand to form an outer shell. The piece was placed inside an autoclave, which can heat the ceramic shell to extremely high temperatures, and the wax melted out. Then molten metal was poured into the mold through the pouring cup, filling the cavity left by the wax. When the metal solidified, the outer shell was broken, revealing the cast object. Vents and pouring cups were cut away. After the cast-bronze pieces were received at the studio, they were sandblasted clean.

Large objects to be cast in the lost-wax method are often cut and cast in smaller sections and then later welded together. However, to maintain the integrity of the doors' delicate surface, all the panels had to be cast as one unit. The two larger panels were sand-cast: these show the manifestations of the Virgin (Apocalyptic Virgin with Shepherdess and Our Lady of Guadalupe), which each measured sixty-by-thirty inches, and the two "grapevine" panels.

To sand-cast these panels, a solid master copy was pulled from the mold using epoxy resin and sent to Montclair Bronze in Montclair, California. At the foundry, the epoxy resin was packed in tempered sand inside a frame and heated, then removed to form a cavity. Pouring cups and risers were added to lift the frame, and molten metal was poured into the cavity and solidified.

For casting the symbols, individual wax squares were pulled from molds and sent to Fenico Precision Casting in Paramount, California.

Several stages of the processes used in creating the doors can be seen in the photograph of Graham's studio. To the left, the latex mold of the grapevine panel is being prepared for an epoxy resin cast. In front, the Virgin of Guadalupe panel is cast in white aqua-resin. In the back, a silicone rubber mold is being applied to the Virgin's skirt.

Blue epoxy was cast to use as a solid "master" for sand-casting.

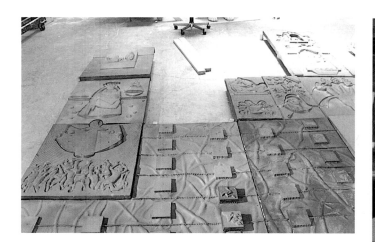

Bronze casts of the Virgin panels

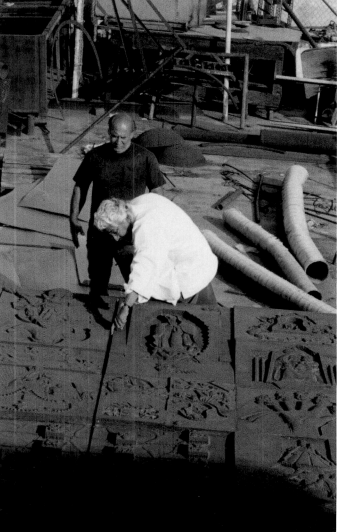

The artist checks the position of the
Virgin panels with Gilad Ben-Artzi,
who assembled and welded the
panels to the stainless steel frame.

The cast panels were sandblasted clean and straightened before they were assembled and welded onto the stainless steel frame. The four-inch cast bronze symbols were individually welded to the grapevine panels. Each door was sandblasted and patina was applied, using chemicals on heated metal surface. To create a unique patina, the artist used a mixture of chemicals. Fertilizer was spread on the bronze panels and left in place for several days. Ferric nitrate, followed by silver nitrate, were applied to produce the silver-gray coloring.

Upper left: Back of the door panels, showing interior framing.

Middle left: Fertilizer was applied as part of the patina process.

Lower left: Patina chemicals were applied to the heated metal.

Below: The assembled bronze panels were sprayed with water.

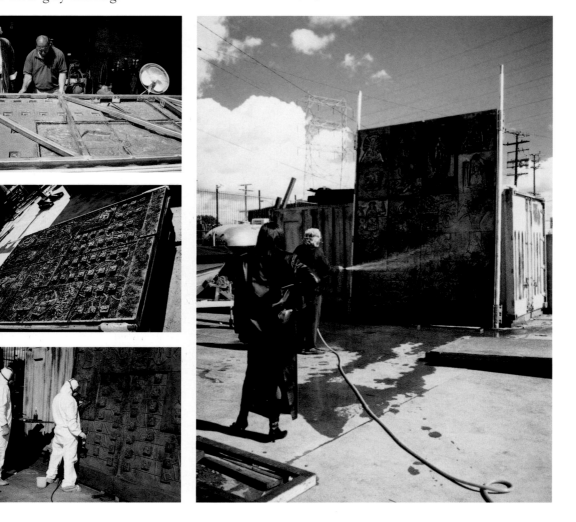

Inner doors, cast in bronze,
December 2001.

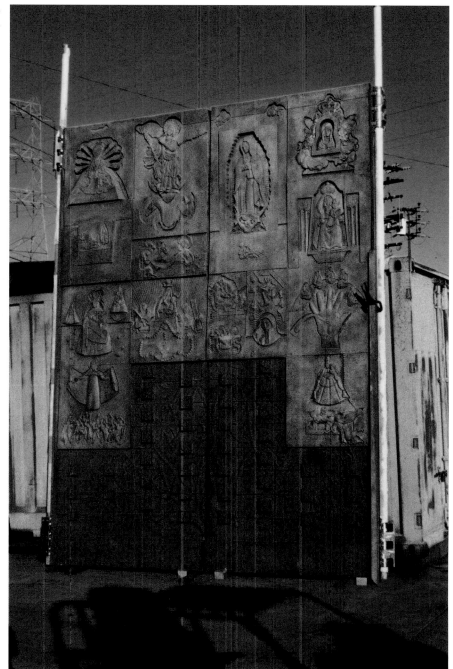

THE VIRGIN FIGURE

As a first step in creating the eight-foot bronze figure of the Virgin, the thirty-inch polyurethane cast was sent to the Scansite facility in northern California, where a high-resolution, three-dimensional scan would be created to enable precise enlargement.

To achieve a flat, even surface for scanning, the figure was first painted gray and fixed in front of the laser scanner. The scanner projected a plane of laser light onto the surface of the figure, as a motion system moved it from side to side. Sensors measured the laser light reflected from the surface and translated the information into numerical data, just as the door panels had been scanned. This process was repeated on different views of the figure until the entire figure was captured in a three-dimensional format. The figure was then cut into pieces for the details of the head, body, arms, hands and feet to be scanned. Then the additional data from these scans were merged with the initial full-figure scan. Four different scanning machines were used on the Virgin figure. Scanners can capture about 15,000 points per second, and the digitized file for the Virgin figure contained over 1.7 million points.

The scanned images can be seen and manipulated in the computer for a wide range of details and surfaces.

A computer-rendered image of the Virgin head with the "polygonized mesh." The full figure was formed from 1,632 patches digitized together.

A detail scan of the arm-lock section of the figure

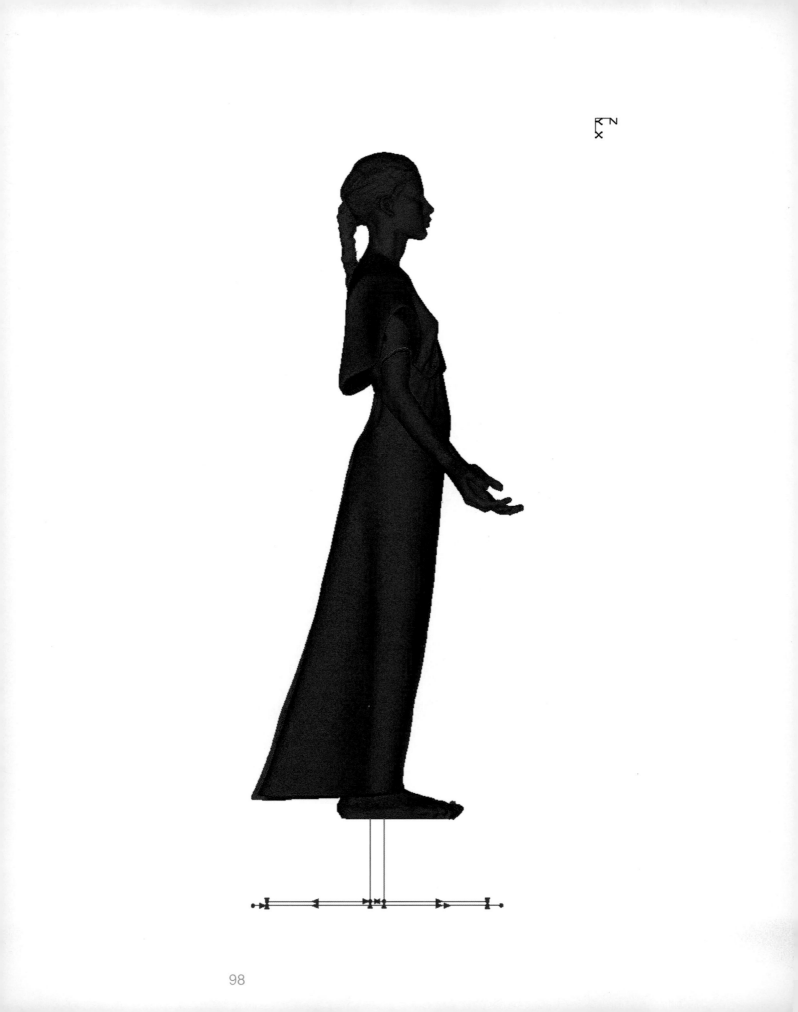

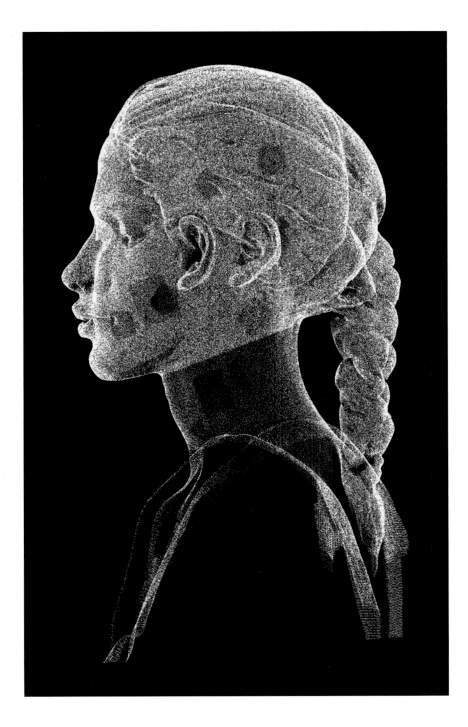

Computer-generated images of the Virgin
figure. This image shows the point cloud data
on the entire head of the Virgin. Only a small
portion of the actual data is shown.

Using the scan data, two studies of the head of the Virgin were milled in plastilene clay in slightly different sizes. In August 2000, the full Virgin figure was milled in clay in four separate sections for casting in bronze. Each section was milled three percent larger than the anticipated finished size to factor in the shrinkage caused by the bronze-casting process.

First the head and bodice were enlarged and milled, followed by the skirt, the feet, and each arm. The milled parts were transported to the studio, where Graham resurfaced the clay by hand, working once again with the young woman who had posed for the initial figure nearly twenty months before.

Information obtained from the laser scans was used to design the full-scale armature.

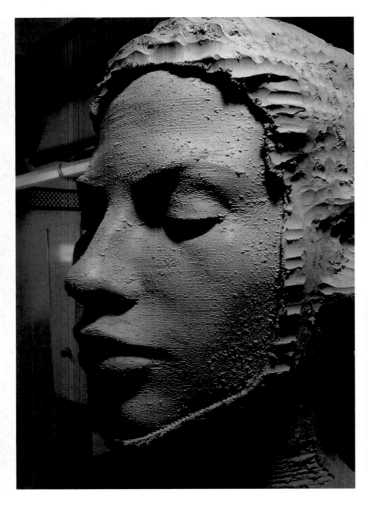

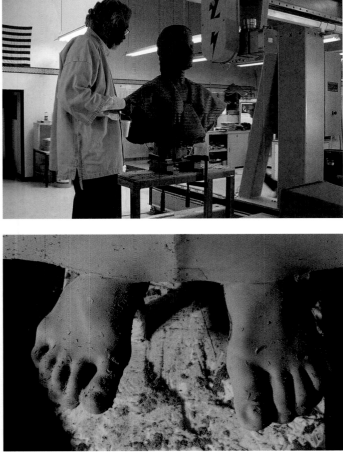

Guided by CAM (computer-aided manufacturing) software, the milling machine repeatedly passes the tool over the clay form, taking away layers of clay and making depth cuts.

Above: The artist checks the progress of the milling process at CTEK.

Below: Detail of the figure on the milling machine.

Upon completion of the milled figures, the silicone rubber molds were made. Waxes were pulled for bronze casting using the lost-wax method and sent to Artworks Foundry in Oakland, California. To avoid cutting and welding the front of the figure, the skirt was sand-cast at Montclair Bronze. All the cast parts were assembled and welded. The finished figure was sandblasted and patinated in silver nitrate.

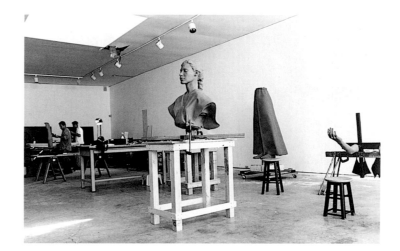

Above, completed figures in plastilene at the studio.

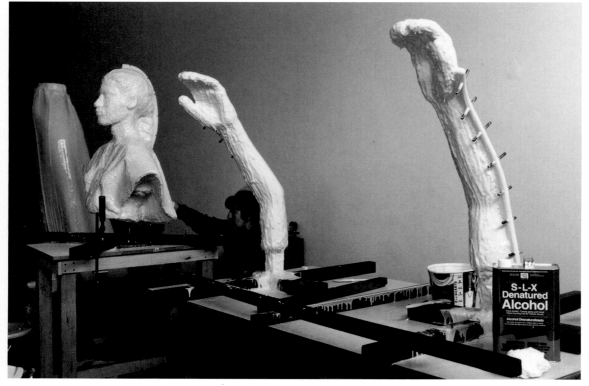

Silicone rubber molds being made.

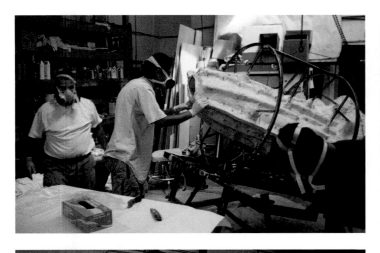

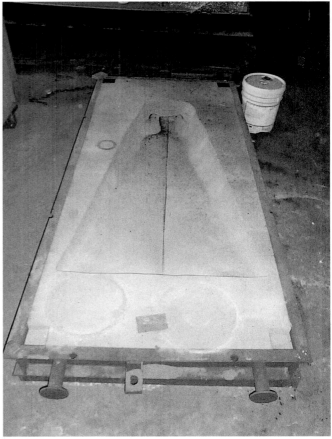

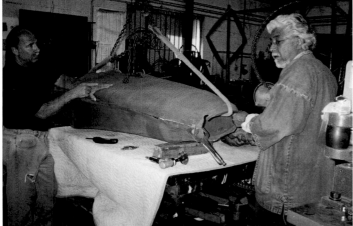

Upper left: Studio assistants pulling an aqua-resin cast from the mold of the Virgin's skirt for sand-casting.

Upper right: Frame for sand casting the Virgin's skirt at the bronze-casting facility.

Lower left: Bronze casts of the Virgin's skirt are joined.

Right: Bronze casts of bodice, arms, and feet prior to welding.

Above: Gilad Ben-Artzi welds the figure.

Below: Jung Yong Chaing grinds the welding marks and repairs imperfections from casting.

Juan Carlos Muñoz Hernandez and Brian Lund assist Gilad Ben-Artzi in assembling the arms.

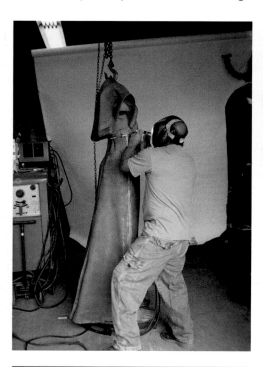

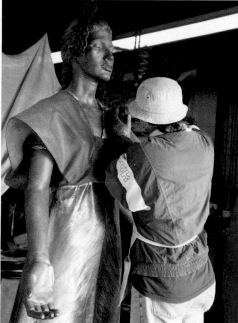

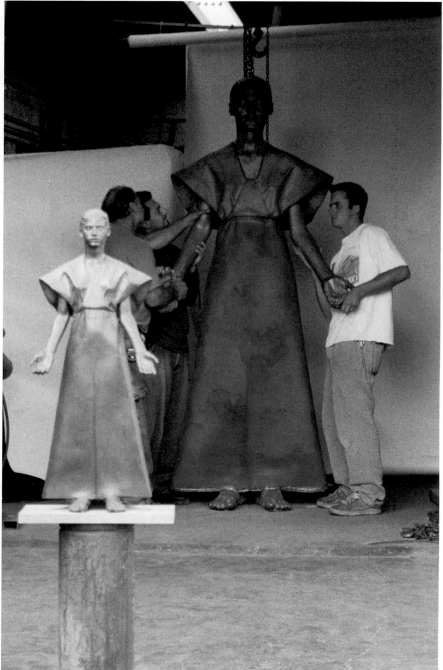

Above: The entire figure is sandblasted using a fine silica sand to achieve a clean, even surface and prepare for the patina application.

Below: Detail of the finished patina.

Silver nitrate was used to apply a patina to the figure. Dan Romo uses a propane torch to heat the bronze to apply the chemicals. After the entire figure is given a patina, a light coat of wax is applied to protect the surface.

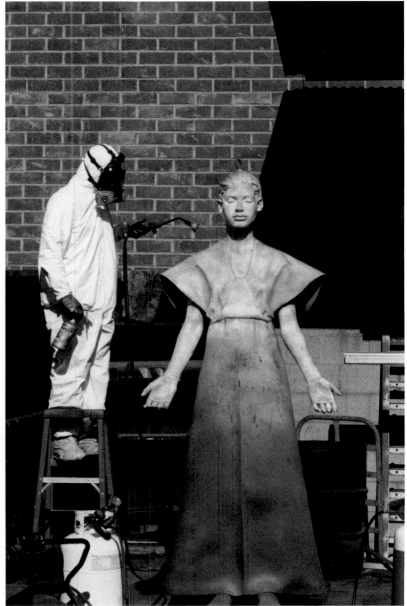

ANGELS

A horizontal figure with extended arms was completed as the study for the angel in 2000. Several designs of the cloak for the angel were made, and the final version, along with the figure, was sent for scanning in February 2001. The twenty-three-inch figure and cloak were scanned separately through the same scanning methods previously used on the Virgin figure. The surface complexity enlarged the digitized file to 1.8 million points. The digitized data was used to create a second angel figure for the left side, a mirror figure to the original for the right side.

The file was transferred to CTEK and reproduced in a 3-D printer, a machine that forms three-dimensional objects from polygonalized scan data, aided by the digital file. The printer spreads a thin layer of plaster powder—then the print head releases a binder solution over the loose powder solidifying the first layer of the object being created. The process is repeated with each successive layer until the object is reproduced. Each layer is approximately .003 to .004 inches. Each angel figure was enlarged to five feet in length and printed in twenty-one separate parts over a period of 235 hours. The finished parts were joined to form nine individual parts for moldmaking and casting.

By the summer of 2001 work on the full-size tympanum was well under way, and Graham could see that the niches for the angels detracted from the power of the Virgin figure. After much consideration the niches were closed and the angels eliminated from the tympanum (see "Our Lady of *Los Angeles*," page 45, note 6).

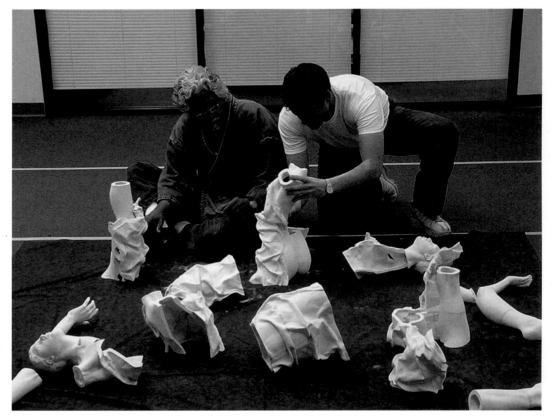

David Bailey of CTEK shows fragments of the angel figure. The plaster sections were built over a period of 235 hours using a 3-D printer.

Details of computer-generated image of the
scan data of the angel.

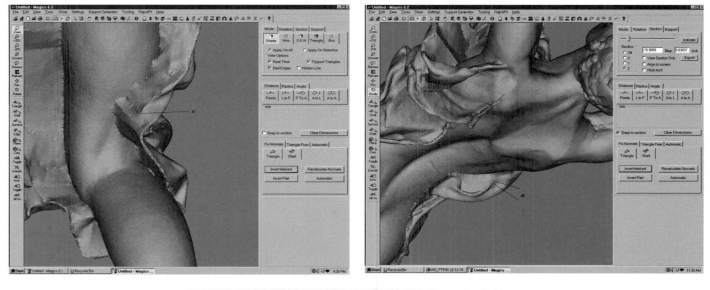

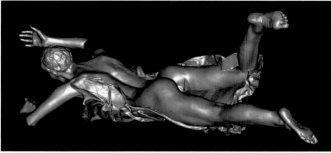

Computer-generated images
of the polygonized data of the
full figure of the angel, back
and front.

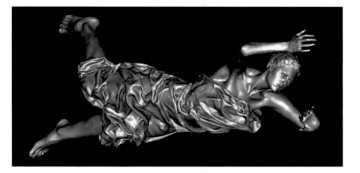

THE DOORS

The Great Bronze Doors are a self-supporting structure at the entrance to the cathedral. A major component of the door project was finding a company in Southern California to engineer and fabricate the massive bronze doors. In early stages of the project, Father Richard Vosko had advised that "the structural, mechanical and code-related factors connected with the design of the doors are very important. The aesthetic issues are equally significant. The doors must be beautiful as well as functional" (letter to Cardinal Mahony, October 9, 1998). Ride & Show Engineering, based in San Dimas, California, was contacted in January 1999. Their proposal to engineer the doors, with driving mechanisms and hidden control systems, was accepted in May.

The structural components and systems for the doors are incorporated within Graham's design and built to last more than five hundred years. The door pivots and motors are hidden within the thickness of the doors and the tympanum. The two large doors along with the two inner doors are electrically driven and controlled to automatically open to predetermined locations or positions.

The driving mechanisms for the large doors are hidden in a moat under the floors. The pivot embeds for lower hinge assembly were designed, fabricated, and installed in the concrete foundation nearly three years before the installation of the doors.

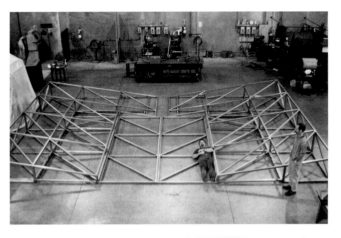

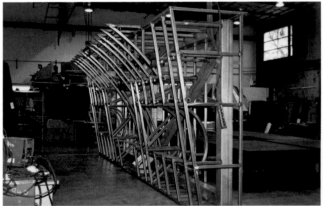

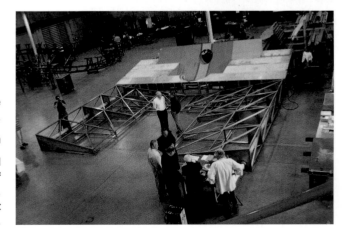

Above: To show scale, Dave Rhea lies on the stainless steel frames.

Middle: The stainless steel tympanum

Right: Cardinal Mahony, Monsignor Kostelnik, and Brother Hilarion view the construction progress of the doors with Robert Graham, Ed Feuer, Garret Rukes, and Roland Feuer at Ride & Show Engineering in San Dimas, California.

The moat is the seismic base-isolation system for the cathedral built around the perimeter from eight- to thirty-feet deep and three- to eight-feet wide. It is designed to allow for lateral movement of up to twenty-seven inches and will withstand earthquakes of up to 8.0 magnitude.

Above: East section view of the doors.

Below: North section view showing the location of the door drive assembly in the moat below the doors.

A section view of the doors in open position.

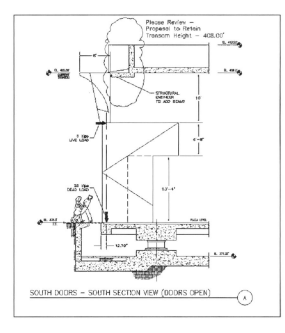

The large motor to operate the doors is placed in the moat below the doors, ready for assembly. The stainless steel pivot extends below the ground.

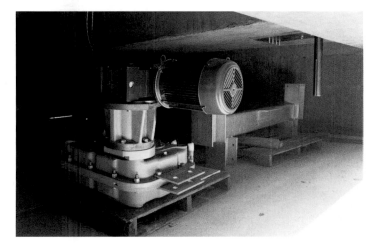

Drawing of the motor assembly for the large doors

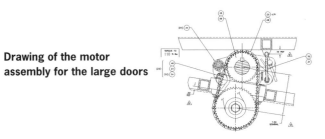

Above: The edge of the tympanum frame

Below: The interior frame for the doors and the tympanum was constructed in stainless steel. Bronze sheets, one-quarter inch thick, were used to clad the front and back of the door in a pattern designed by the artist.

From left to right, Garret Rukes, Father Richard Vosko, and the artist meet at the Ride & Show Engineering facility.

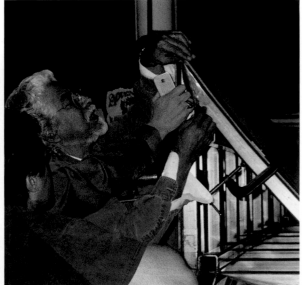

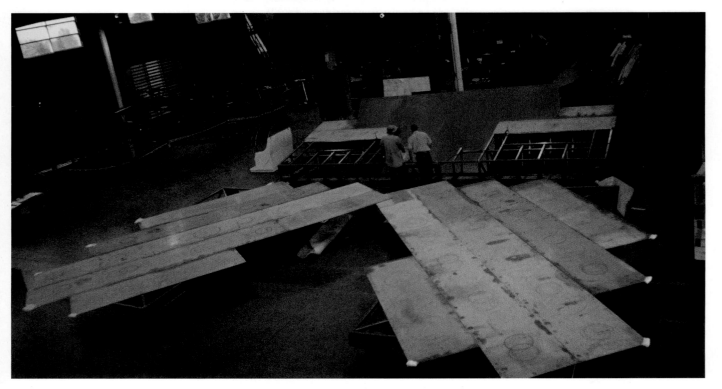

Drawing of the motor assembly
for the inner doors

Above: The artist with Jesus Diego, checking
surface irregularities on the bronze sheets.

Below: The tympanum and the outer doors

Suction cups were used to lift
the bronze sheets in place.

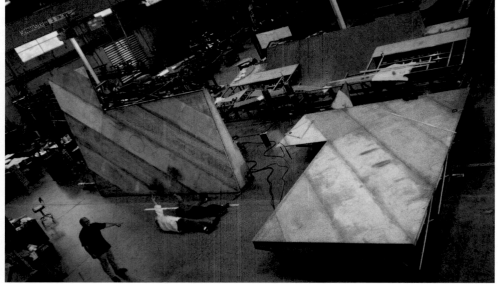

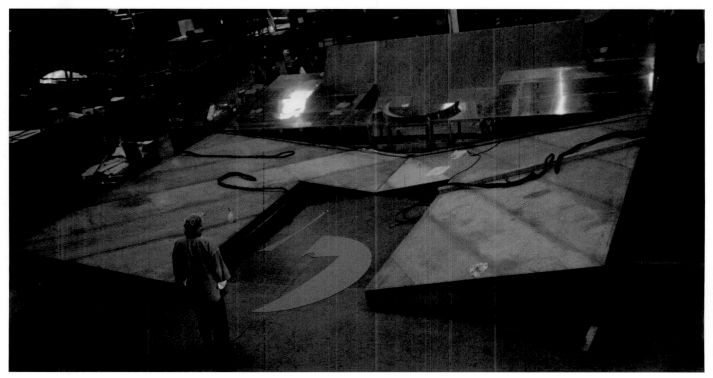

Upper left: The doors are moved to the exterior of the building using a forklift and crane.

Middle: Gonzalo Algarate, Dave Rhea, and the artist watch as the crane picks up one of the doors.

Lower left: A crane lifts the large door panel to the outdoor frame.

Jesus Diego and Dave Rhea complete the welding on the temporary frame to install the doors in position.

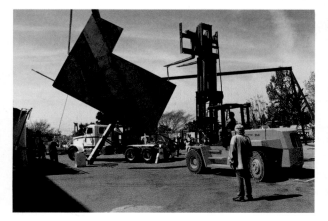

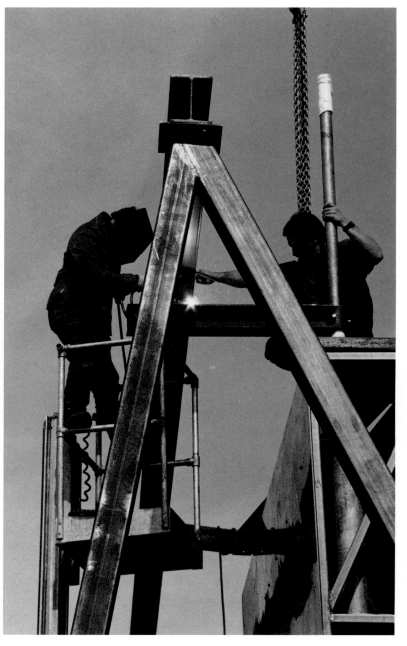

Below: **Back view with small motors visible at the top of the inner door pivots. The motor is concealed in a space inside the large doors. The bronze panels were patinated to a dark brown color.**

The doors are moved in position on the frame.

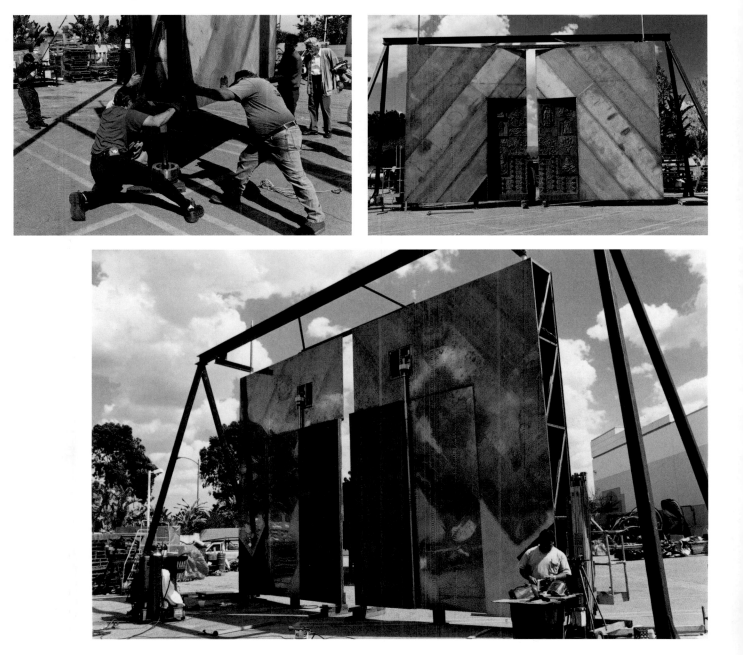

The inner doors were brought to San Dimas, and a steel frame was built in the outdoor yard to bring the two doors upright and facing east, in the same orientation as the cathedral.

The front and back surfaces of the outer doors and tympanum were hand-ground to a smooth finish. A chemical mixture of cupric sulfate and phosphoric acid was applied to achieve a dark brown patina. The bronze was heated, and a thin coat of wax was applied to seal and protect the surface.

The tympanum surrounding the Virgin figure was gilded using 22-carat Italian gold leaf, hand-applied in $3^{3/8}$ inch square leaves over a surface of approximately 150 square feet and sealed for preservation. The Virgin figure was transported to San Dimas and secured to the tympanum.

Patina being applied to each bronze section, above. The hand-grinding process is reflected on the metal, right.

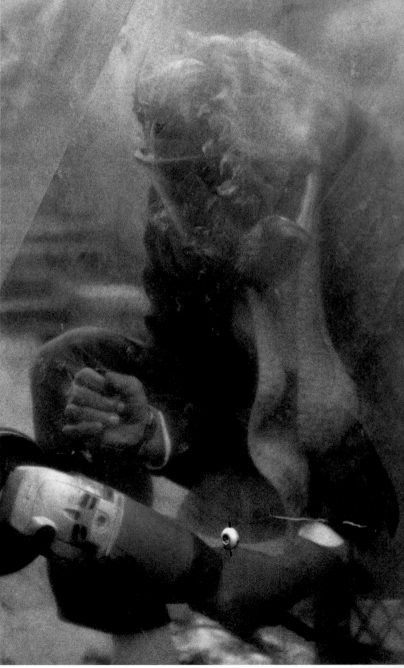

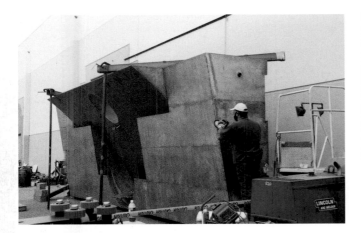

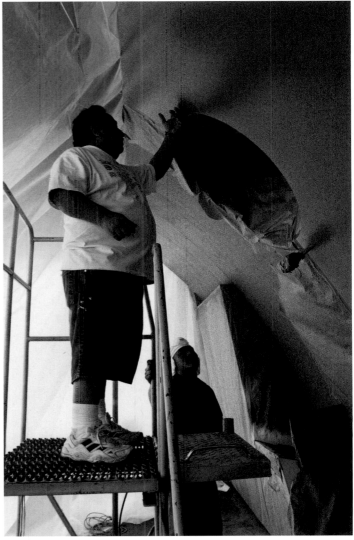

Above: Paco E. Vasquez and Rogelio Ramirez apply gold leaf to the tympanum.

Upper left: The tympanum being finished and prepared for gilding.

Middle: Detail of the moon on the tympanum.

Left: The artist's equipment cart.

INSTALLATION

On May 19, 2002, Cardinal Roger Mahony blessed the doors and the tympanum for its safe journey to the cathedral. The next day, the doors were removed from the temporary position, and transported in three sections, each on an oversized flat-bed truck. A third truck carried the tympanum with the Virgin figure.

The Great Bronze Doors:
Measurements and Weight

TYMPANUM
21,040 lbs.
10 feet high by 30 feet long,
extending 76 inches
at the top center

OCULUS
34 inches in diameter

VIRGIN FIGURE:
1,000 lbs.
8 feet high

OUTER DOORS
10,680 lbs. each
20 feet high by 15 feet wide

INNER DOORS
Left door: 3,260 lbs.
Right door: 3,380 lbs.
15 feet high by 5 feet wide

The doors are 30 inches thick at
the pivot, tapering to 1 inch
where they meet in the center

Total weight: 50,040 lbs.
(25 tons)

The finished tympanum.

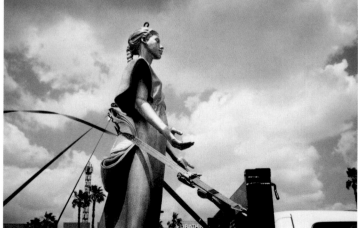

The Virgin figure being transported from Graham's studio to San Dimas, California.

The blessing of the doors on May 19, 2002. The crowd gathers around Cardinal Mahony and Monsignor Kostelnik.

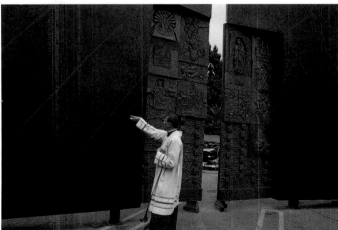

The door section is lifted from the frame and placed on a flat-bed truck.

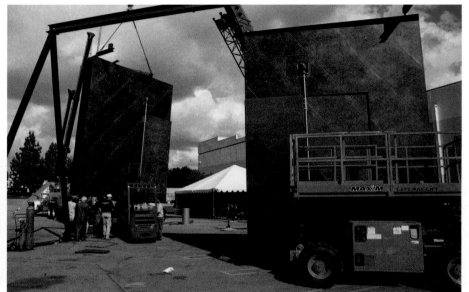

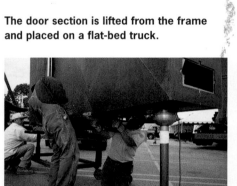

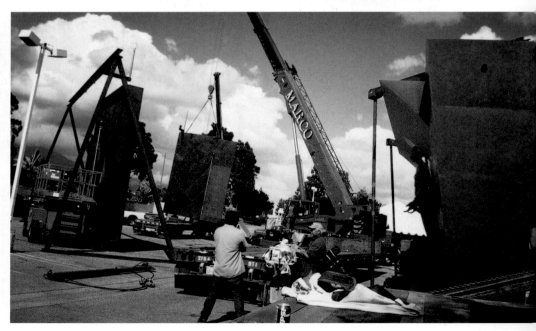

Slightly past midnight on May 21, the flat-bed trucks, along with a convoy of pick-up trucks and a van carrying the artist, traveled the fifty-mile distance from San Dimas to the cathedral in Los Angeles on surface streets through the communities of Pomona Valley, San Gabriel, East Los Angeles, and over the First Street Bridge into downtown, arriving at the Cathedral at 3:06 a.m. Unloading and installation began immediately.

Tympanum on Temple Street in downtown Los Angeles.

Installation at the cathedral on May 21, 2002. Two large doors are installed. The tympanum was lifted in place by a crane and lowered onto the pivot and secured to the metal brackets visible on the photo at right.

The back of the doors seen from inside the cathedral.

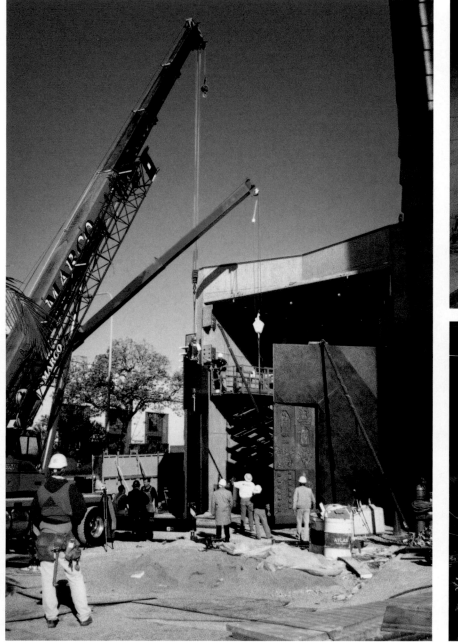

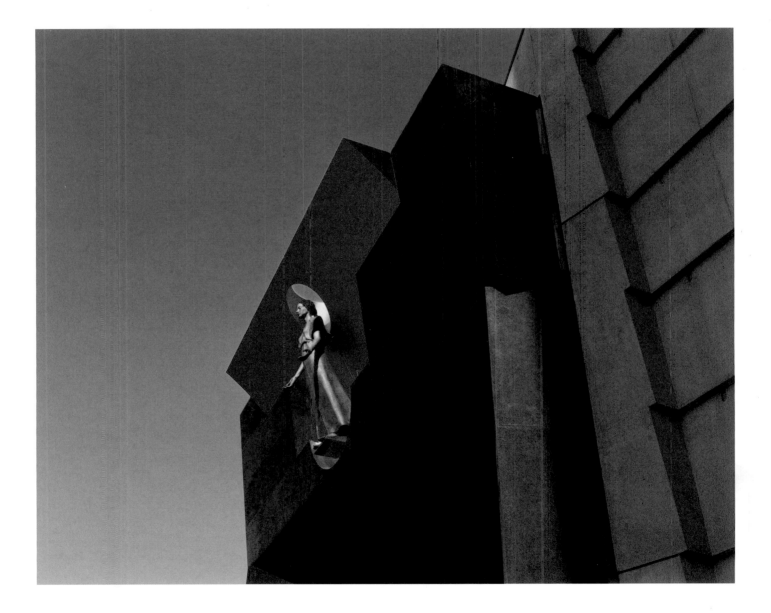

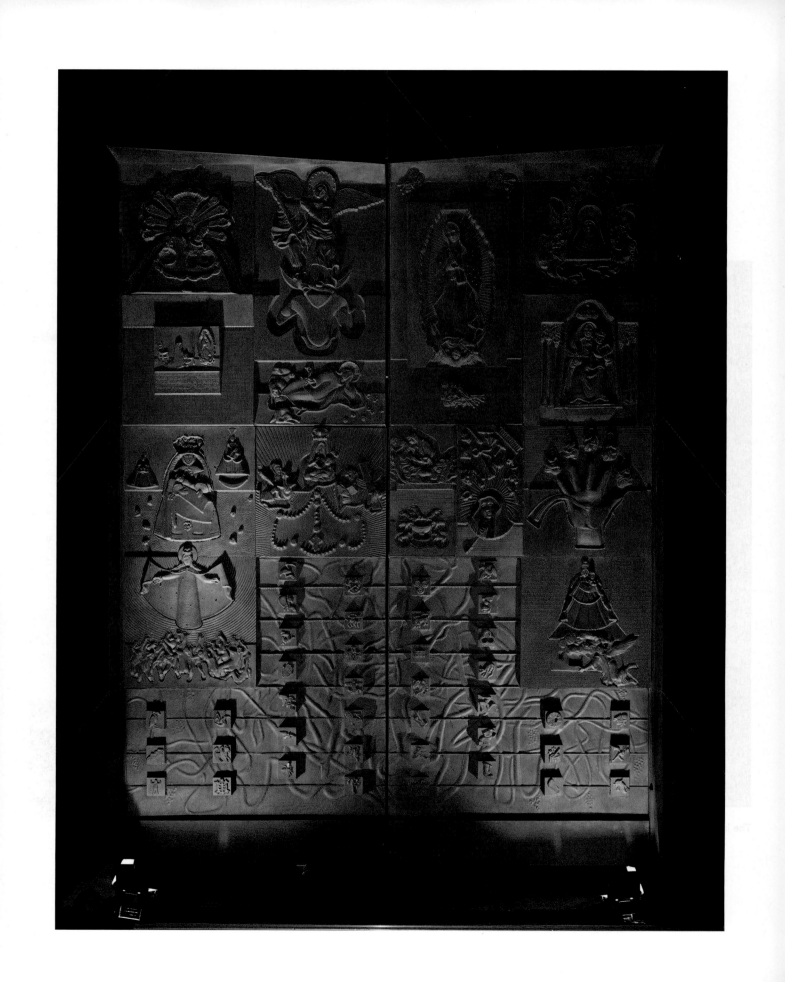

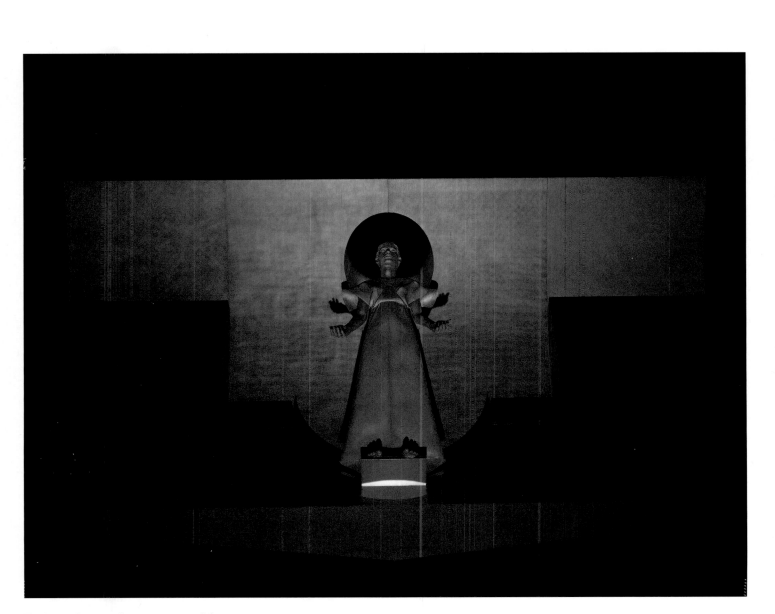

The inner doors and tympanum at night.

ACKNOWLEDGMENTS

I thank equally the following people, as their efforts, big or small, were responsible for the realization of this project.
—Robert Graham

Archdiocese of Los Angeles
His Eminence, Cardinal Roger Mahony, Archbishop of Los Angeles
Reverend Monsignor Kevin Kostelnik, Pastor, Cathedral of Our Lady of the Angels
Brother Hilarion O'Connor, O.S.F.
Russ Pittelkau

Designer and Consultant for Worship Environments
Reverend Richard S. Vosko

Leo A Daly
David Arredondo
Leo A. Daly III
Nicholas Roberts
John Williams

Stegeman and Kastner
R. Randall Fulton

Art and Furnishings Committee of the Cathedral of Our Lady of the Angels
Sir Daniel Donohue
Linda Ekstrom
Lalo Garcia
Walter Judson
Reverend Monsignor Kevin Kostelnik
Edward Landry
Kathleen McCarthy
Edith Piczek
Gayle Roski
Reverend Richard S. Vosko

Robert Graham Studio
Dora Arevalo
Raul Caballero
Marnie Castor
Gina Clark
Noriko Fujinami
Steven Graham
Sam Gehry
Helena Kallianiotes
Nick Kottek
Valentin Limon
Jaime Lopez
Sebastian A. Lopez
Sebastian Lopez Jr.
Brian Lund
Rebecca Martinez
Richard Mesa
Juan Carlos Muñoz Hernandez
Laila Nabulsi
Tadi Olguin
Rafael Rodriguez
Laura Weikel
Maria Weikel

Amazing Steel
James Mitchell

Artworks Foundry
Nick DiPhillipo
Lewis Jefferson
Brian Koster
Leon Lackey
David Muela
Piero Mussi
Jose Refugio
Tom Schrey
Tim Soucy
Penpa Tsering

Berwick Productions
David Riley

Capture 3-D
Johan Gout
Ron Gout
Rick White

Chaing's Art Studio
Jung Yong Chaing

City of Paris Studios (COPS)
Dan Romo

CTEK
Eric Adickes
Sal Aguillon
David Bailey
Jesse Burnett
James Cournyer
Todd Gionet
Felicia Hernandez
Leo Iezzi
Mauricio Olalde
Carlos Platero
Terrence Robinson
Luis Salazar
Terry Stucker
Javier Valdivieso
Brandon Wilkie

Creative Enterprises
Gilad Ben-Artzi

Custom Cabinets Carpentry
Richard Mercado

Dalton Trucking
Chris Bowman
Bill Moyer
Wes Stevens

Dan's Custom Metal
Daniel Nunez

Fenico Precision Casting
Anna Garcia
Gary Gunning
Bruce Nesmith
Don Tomec
Sherry Tomeo
Ruben Toscano
Jonny Tran
Freddy Vega

G.A. Designs
Gonzalo Algarate
Sandra Algarate
Oscar Alvarez

**The J. Paul Getty Museum
and Research Institute**
Peggy Fogelman
Peter Fusco
Mark Henderson
Jack Miles
Kevin Salatino
Tracy Shuster

Gold leaf application:
Jesus Gonzalez
Carlos Quintero
Adriana Ramirez
Alfredo Ramirez
Rogelio Ramirez
Paco E. Vascuez

Gray Angel Productions
Jaclyn Bashoff
Gwenn Stroman

Lighting design consultant:
Joe Kaplan

Marco Crane & Rigging Company
Brandt Bankston
Brett Dean
Mike Dean
Alex Ortega
Scott Stevens

Montclair Bronze
Manuel Cortez
Jeffrey Crumbaker
Thomas Freeberg
Wayne Freeberg
Jose Garcia
Alfonso Guerra
Pedro Noriega
Raul Robles Flores

Ride & Show Engineering
Andreas Bernsau
Rogelio Betancourt
Luke Blair
Ron Brown
Dale Cheatham
Jesus Diego
Susan Estrada
Eduard Feuer
Margarete Feuer
Roland Feuer
Greg Fries
Allen Giswein
Russ Hanssens

Michael Harrington
Frank Lawrence
Steve Leon
Ian Hueih-Shing Lin
Eldon McColl
Alejandro Mimila
James Olsen
Richard Pera
Dave Rhea
Hamid Romouzi
Vladimir Roschupkin
Garret J. Rukes
Celito Saldivar
Matt Sellers
Sabu Sims
Michael Sullivan
Atanacio Tristan

Safe-way Sandblasting
Daniel Merino R.
Espiridion Polanco
Juan Carlos Saucedo D.

Scansite
David Bassett
Lisa Federici

In addition:
Tony Berlant
Julie Corman
Carol and Roy Doumani
Anjelica Huston
Noelle Lippman
Michael Minukin
Ed Moses
David Novros
Jeremy Railton
Arnold Schwarzenegger
Maria Shriver

ABOUT THE AUTHORS

Jack Miles, Senior Advisor to the President of the
J. Paul Getty Trust, is the author of *God: A Biography,*
which won a Pulitzer Prize in 1996 and has been
translated into sixteen languages, and its 2001 sequel,
Christ: A Crisis in the Life of God.

Peggy Fogelman is the Assistant Director for
Education and Interpretive Programs at the
J. Paul Getty Museum. From 1987 to 2000 she
served as museum's Associate Curator of
European Sculpture.

Noriko Fujinami is the Director of Robert Graham Studio.

BIOGRAPHY

The artist, May 21, 2002

Robert Graham was born in Mexico City in 1938 and studied at San Jose State College (B.A., 1961–1963) and the San Francisco Art Institute (M.F.A., 1963–1964.) Since 1964, his work has been the subject of more than eighty solo exhibitions and two retrospective exhibitions in the United States, Europe, Japan, and Mexico. His work is part of many national and international museum collections.

CIVIC MONUMENTS:

1984 *Olympic Gateway* to commemorate the XXIIIrd Olympiad in Los Angeles, California
1986 *Monument to Joe Louis* in Detroit, Michigan
1994 *The Plumed Serpent* in San Jose, California
1997 *Franklin Delano Roosevelt Memorial,* Washington, D.C., "First Inaugural" and "Social Programs"
1997 *Duke Ellington Memorial* in New York City's Central Park
1999 *Charlie 'Bird' Parker Memorial* in Kansas City, Missouri
2001 "Prologue" to the *FDR Memorial*, Washington, D.C.
2002 *Great Bronze Doors* for the Cathedral of Our Lady of the Angels, Los Angeles, California

PUBLIC INSTALLATIONS OF SCULPTURES:

Los Angeles: *Dance Door* at the Music Center Plaza; *Fountain Figures I-IV* at the Wells Fargo Plaza; *Source Figure* at the First Interstate World Tower in downtown; *Dance Columns I and II* at the Franklin Murphy Sculpture Garden, *Model for Duke Ellington Memorial* at Schoenberg Hall, Doumani Sculpture Garden at Rolfe Hall, all at University of California at Los Angeles; *Retrospective Column* at the Los Angeles County Museum of Art.

Northern California: *Column* at Federal Reserve Bank in San Francisco; *San Jose Fountain* at the U.S. Courthouse/Federal Building in San Jose.

Seattle: *Dance Columns* at the Wright-Runsted Building.

ARCHITECTURAL PROJECTS:

Doumani House and Huston-Graham House, both in Venice, California.

Robert Graham designed the National Medal of Arts, presented yearly by the President of the United States; the Spirit of Liberty Award presented by the People for the American Way; the California Governors' Award for the Arts; the John Huston Award for Artists Rights Foundation; and the Gabi Award for the Los Angeles Latino International Film Festival. In 1993, Robert Graham received the ACLU Freedom of Speech Award and the California Governor's Award for his outstanding contribution to the arts.

He works and lives in Venice, California.

www.robertgraham-artist.com

IMAGE CREDITS

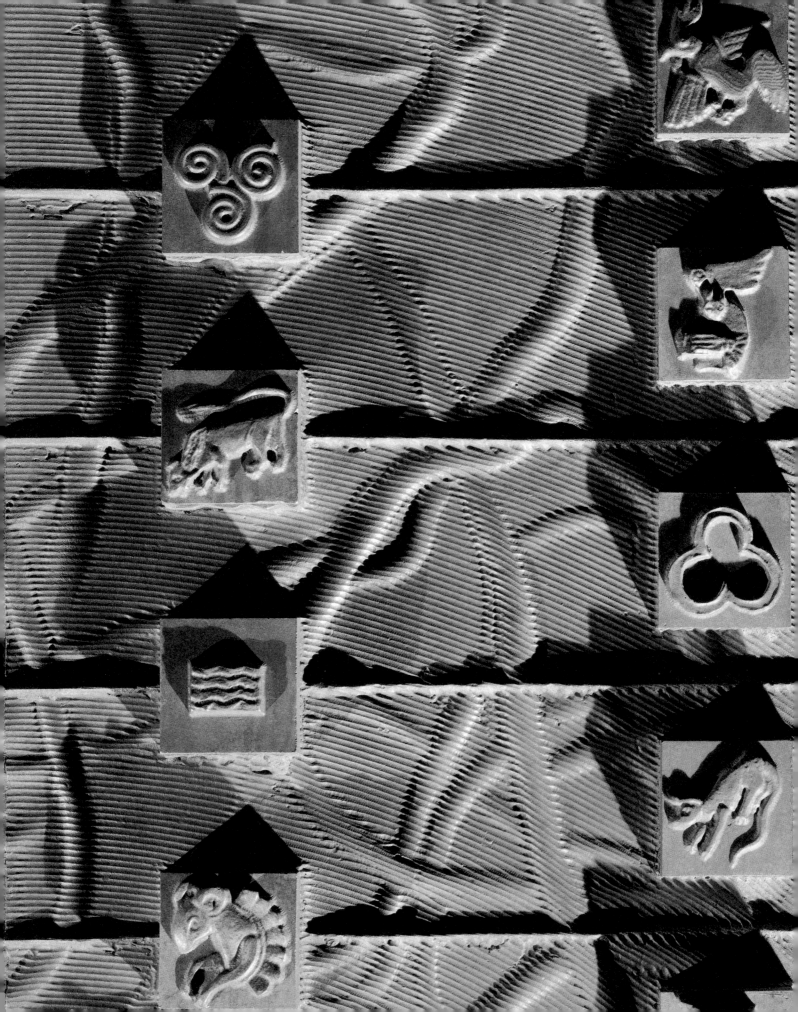